ROBERT WHITE

D0562385

Discovering
Cameras
1945-1965

SHIRE PUBLICATIONS LTD

Published in 2001 by Shire Publications Ltd, Cromwell House, Church Street, Princes Risborough, Buckinghamshire HP27 9AA, UK. Website: www.shirebooks.co.uk
Copyright © 1995 by Robert White. First published 1995; reprinted 2001. Number 286 in the Discovering series. ISBN 0 7478 0298 X.
Robert White is hereby identified as the author of this work in accordance with Section 77 of the Copyright, Designs and Patents Act 1988.

All rights reserved. No part of this publication may be reproduced or transmitted in any form or by any means, electronic or mechanical, including photocopy, recording, or any information storage and retrieval system, without permission in writing from the publishers.

Printed in Great Britain by CIT Printing Services Ltd, Press Buildings, Merlins Bridge, Haverfordwest, Pembrokeshire SA61 1XF.

British Library Cataloguing in Publication Data. White, Robert. Discovering Cameras, 1945-65. – (Discovering Series; No. 286). I. Title II. Series. 771.309. ISBN 0-7478-0298-X.

ACKNOWLEDGEMENTS
I am very grateful to Mike Hanson, Tom Samson, Harry Shaw, Barry Spencer and John Wade for providing cameras for the illustrations and to Max Dyble for taking the cover photograph. Christies have very kindly provided the photographs for plates 6, 23 and 53; and for permission to use line illustrations from their publications I thank the Leica Camera Company (plate 44), Kodak Ltd (plates 3 and 15) and the *Amateur Photographer* (plates 4 and 5). I offer my special thanks to Derek Dewey-Leader and Mike Rees, who read and corrected the original text and provided many valuable suggestions for improvements.

Cover photograph: *(From left to right: back row) Polaroid 95, Semflex Automatic, Bessa II; (middle back row) Brownie F, Canon VIT, Hasselblad 1000F; (middle front row) Contax S, Wray Stereo Graphic; (front row) Yashica 16, Olympus Pen.*

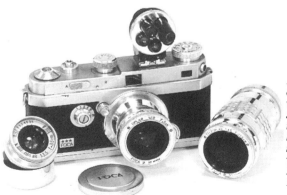

1. Foca PF3 camera with wide-angle, standard and telephoto lenses with multi-focus viewfinder. French, about 1952.

Contents

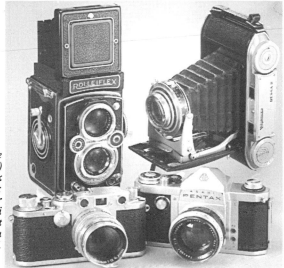

2. (Clockwise from top left) Rolleiflex Automat; Voigtländer Bessa II; Asahi Pentax, first model; Leica IIIf.

1

Introduction

An earlier Shire Publications book, *Discovering Old Cameras 1839-1939*, covered the development of the camera during the first hundred years of photography. This book deals with cameras during a much shorter period, the twenty years from the end of the Second World War in 1945 up to 1965. Although twenty years does not seem to be a very long time, enormous changes in both cameras and photographic processes occurred in those two decades. Thousands of different cameras were made during the period and in this book it has been possible to include only a small, but representative, selection. Chapter 9 contains a list of specialist books which deal with the cameras of particular countries or makers in more detail.

Economic background

When the war finished in 1945 most major European countries and Japan were left with their production capacity seriously disrupted by war damage and lack of both raw materials and skilled manpower. Huge national debts or war reparations had to be paid off. In September 1945 American Lend Lease aid to Britain stopped and it took five years to repay the debt. European reconstruction received an enormous boost from the American Marshall Plan of June 1947, which pumped millions of dollars into the purchase of new capital equipment.

However, the communist takeover in Hungary and Czechoslovakia, the Berlin Blockade of 1948 and the start of the Korean War in June 1950 diverted funds away from domestic production towards defence expenditure. Throughout the later 1940s and early 1950s Britain went through a succession of major economic crises; rationing was still tight until 1950 but had all but gone by 1953, when the British at last started to sense a general feeling of improved prosperity. As Britain's fortunes were reviving, so too were those of the other countries of Western Europe and of Japan, which all benefited from American help. Japan was occupied by American forces until 1950 but during the years of occupation a great deal of financial and technical aid was provided, including advice on the techniques of improving the quality of manufactured goods, which was to prove crucial to the later success of Japanese cameras and other goods manufactured for export.

Britain, in common with France and a number of other countries, had to make goods for export at the expense of supplying the home

market. At the same time imports had to be restricted to raw materials for essential home use and for turning into export goods. High purchase tax, between 50 and 66 per cent, damped down home demand and it was only after about five years that cheap foreign cameras were allowed into the country. When they did arrive they suffered an import duty of 50 per cent. Even by the mid 1950s only cameras with an ex-factory price of £5 10s 0d in Germany were allowed to be imported freely into Britain, where the addition of importers' and dealers' costs and profit, plus the import duty and purchase tax, pushed the price to the British customer up to £20 to £25. At that time the annual pay for semi-skilled workers was around £500 a year, a shop assistant received nearly £400, a skilled mechanic was paid £650 and a senior civil servant might have earned around £2500 to £3000. More expensive cameras were imported only on a very restricted quota, although professional photographers and industrial and research laboratories could apply to the Board of Trade for an import licence. Not until the later 1950s were restrictions on German cameras eased to allow sufficient imports to meet most demands. A limited quota of Japanese cameras was allowed only at the end of the 1950s but all restrictions were lifted by about 1962.

The contrast with the United States was marked; there importa-

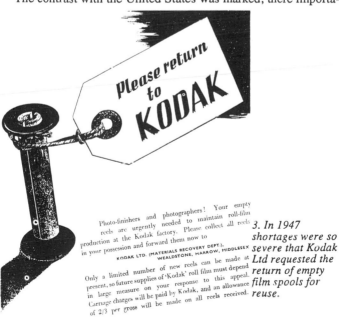

Photo-finishers and photographers! Your empty reels are urgently needed to maintain roll-film production at the Kodak factory. Please collect all reels in your possession and forward them now to

KODAK LTD. (MATERIALS RECOVERY DEPT.), WEALDSTONE, HARROW, MIDDLESEX

Only a limited number of new reels can be made at present, so future supplies of 'Kodak' roll film must depend in large measure on your response to this appeal. Carriage charges will be paid by Kodak, and an allowance of 2/3 per gross will be made on all reels received.

3. In 1947 shortages were so severe that Kodak Ltd requested the return of empty film spools for reuse.

tion was unrestricted and prices were much lower. For example, the British magazine *Amateur Photographer* cost one shilling in 1949; it had about fifty-six medium-format pages and the few new cameras advertised were of British manufacture. Of those only the cheap box cameras were freely available. A second-hand pre-war Contax III camera cost about £140 and a 1939 Rolleiflex Automat camera was around £100. The American publication *Popular Photography* cost 25 cents and had 184 large-format pages, eight in full colour; it was full of advertisements for new cameras from Europe and the USA. A brand-new Leica IIIc camera was $280 and a Rolleiflex Automat cost around $200. The pound had just been devalued from $4.03 to $2.80.

Films

Good colour slide films had reached the market in the mid 1930s but it was still very expensive to make a decent colour print. By 1947 films and papers were on the market in the USA for both trade and home processing of colour prints from colour negatives. By 1952 the British Pakolor process was available in the United Kingdom. A roll of 120 film cost 16s 3d, development was 6 shillings and contact prints 6 cm x 9 cm were 2s 6d each. Only in 1957 did Kodacolor come to Britain. Kodacolor contact prints cost 1s 3d in 1961. Black and white film remained popular throughout the period and significant improvements were made in film speed and fineness of grain. At first several film speed standards were in use such as Weston, the German DIN, British Standard, American Standard or ASA, Scheiner, Ilford Speed Groups and so on. For some black and white films, especially those popular with snapshot makers, the film speed included a generous safety margin since it was much easier to get a good contact print from an overexposed negative than from one which had been under-exposed. In time, especially when accurate exposure meters came into common use, the safety margins were removed and the DIN and ASA became the most widely accepted standards.

Flash photography

When a flash photograph is taken the shutter has to be fully open when the light from the flashgun is at its most brilliant. Large, single-use flash bulbs take a fraction of a second before peak brilliance is reached. To be certain that the maximum light output has been reached when the picture is taken the electrical circuit used to fire the bulb has to be completed a few thousandths of a second before the shutter starts to open. However, the flash from an electronic gun is produced without any delay, and the circuit must be closed only when the shutter is already open. Flash-

synchronised shutters were provided with an X setting for electronic guns and an M setting for larger flashbulbs. Some smaller flashbulbs burned so quickly that they, too, were used with the X setting. At first there were a number of different sockets and plugs for connecting cameras to flashguns. Eventually the co-axial 3 mm connector came to be used by all makers. Some American cameras had flash contacts built into the centre of their accessory shoes from the late 1930s. The use of the Hot Shoe, as it became known, widened only slowly after the war but it was increasingly used in the 1960s, especially in Japan.

Electronic flashguns were available soon after the war ended but the early models needed large batteries to generate sufficient power. They were restricted to studio use or required the photographer to carry a heavy pack of rechargeable cells. By the early 1950s they became much smaller when high-voltage dry batteries became available and the later inclusion of transistors in the circuit allowed the invention of small lightweight guns. Flashbulbs were relatively expensive, especially in the larger sizes. Cheaper, smaller bulbs were introduced which had enough power for snapshots to be taken at reasonably close distances. In 1955 costs were further reduced after the metal cap at the base of the bulb was dispensed with; a couple of bare wires, either side of the glass at the base of the bulb, were sufficient to provide the electrical contact. A small PF1 bulb then cost 8d; the addition of a blue coating, to give the correct balance for colour films, added one penny to the price. In the early 1960s the Flashcube was introduced which held four miniature flashbulbs, one in each face of a cubical housing.

Camera design features

During the 1950s smaller-format cameras were in demand, especially those taking 35 mm film, and particularly by users of colour slide film. For most of the 1950s photographic prints were made by contact, which gave a picture the same size as the negative, so larger cameras taking negatives 6 cm x 9 cm and 6 cm x 6 cm remained popular. By the late 1950s many processing houses were offering en-prints, small-scale enlargements from the whole of the negative, at a price little above that of a contact print. By then the lower cost per negative from small-format cameras, combined with low-cost en-prints, led to the replacement of larger roll-film cameras by smaller models even for snapshots.

To speed up the operation of 35 mm cameras, levers began to replace knobs for winding films from around 1954 although it was to be a few years before the lever was a standard feature. The handy little cranked lever for winding the film back into cassettes started a year or two later; it became a standard feature of Japanese

cameras before it was regularly adopted in Europe. Quick-loading cartridges were introduced in the 1960s, mainly for snapshot cameras, but by 1965 a quick-loading method was made by Canon for 35 mm film in standard cassettes.

Exposure meters became small enough to be built into 35 mm cameras from around 1953. To make it easier to transfer readings from the tiny scales, the Light Value or Exposure Value system was introduced, although it seemed to confuse as much as help. The meter reading gave a single number, say 12. A pointer was moved to line up the number 12 on the combined shutter and diaphragm control. This provided a number of combinations of shutter speeds and f stop numbers, which all gave the same exposure: for example 1/60th second at f8, 1/125th second at f5.6, 1/250th second at f4 and so on. To make the Exposure Value system function it was necessary for shutter speeds exactly to double from one to the next. The old scales of 1/2, 1/5th, 1/10th, 1/25th and 1/50th second were replaced by 1/2, 1/4, 1/8th, 1/15th, 1/30th and 1/60th. Exposure Value shutters did not last for long. Automatic and semi-automatic exposure systems, at first derided by experienced photographers, became popular after their inclusion in cameras from the late 1950s; by the early 1960s they were commonplace. Small and very sensitive cadmium sulphide or CdS meters were built into cameras from the early 1960s, and by 1963 the first through-the-lens metering, single-lens reflex camera was marketed.

Camera lenses

The introduction of anti-reflection coating for lens surfaces during the war and the availability of new optical glasses made it possible to produce lenses capable of good results at moderate prices. However, camera makers recognised that lenses with large maximum apertures were regarded as a form of status symbol by some photographers and, rather unwisely, a number of cameras were fitted with f2.8 lenses of indifferent quality rather than with f3.5 lenses with good optical properties. The great increase in numbers of cameras which would accept interchangeable lenses led to a rapid growth in the availability of wide-angle and telephoto lenses both from camera makers and from independent suppliers. There was very little standardisation in mount size. Leica copy cameras had Leica fitting screw threads and the 42 mm screw thread was used by a few makers of single-lens reflex cameras. There was practically no standardisation of bayonet mounts between different makers even if they used the same make of shutter.

The use of the electronic computer reduced the cost of the design work needed to compute good lenses which could be sold at

reasonably low prices. The most difficult ones to design were zoom or variable-focus lenses. The first zoom lens for a still camera was made by Voigtländer under licence in 1960. It was large, heavy and, at around £160, it cost a good deal more than the camera body to which it was fitted. Moreover, its optical properties fell short of the standards of fixed focal length lenses. However, slowly at first, but then more quickly, lighter and cheaper zoom lenses became competitive in both price and optical quality. Although plastic-moulding technology improved considerably it was not possible to make plastic lenses which could match glass ones. However, moulded-plastic optical systems were used in viewfinders and some plastic lenses were used in simple snapshot cameras such as the Kodak Brownie 44A.

Camera-producing countries

Although many countries produced cheaper cameras for domestic sales before the war, Germany dominated the market for quality items. At the end of the war Germany was devastated and, although not all of the camera factories had been destroyed, it was a year or two before production could restart in any significant way. American, British and French camera producers believed they had the opportunity to expand their businesses, especially for precision miniature cameras, which had been a German speciality. Photographic magazines of the time were quick to praise any new camera, shutter or lens of domestic origin and to emphasise that the quality and results matched or exceeded those of similar German cameras.

American makers had a head start since their industry was intact and there were few supply problems. Large numbers of snapshot and other simple cameras were made by a dozen or more producers. 35 mm cameras had been made in the USA before the war by one or two companies and quite soon more joined in. Plenty of domestic twin-lens reflex cameras were also available. Not much originality was shown in the designs. By and large they were robust and worked well but they seemed to lack the finesse, novelty and elegance of the pre-war German cameras. By the early to mid 1950s, when the new German designs were arriving, as well as cheap but good Japanese cameras, the American industry began a slow decline, lasting into the 1960s.

The makers in France resumed production quite quickly. Some had secretly been working on designs during the German occupation and the country had good supplies of aluminium, which suited the construction of miniature cameras. About a dozen makers made the whole range from simple box cameras to roll-film twin-lens reflex cameras and coupled rangefinder 35 mm models. By

the later 1940s they were exporting them to the USA and Europe. The Semflex and Foca cameras did particularly well and were still on sale in 1965. In Czechoslovakia the Meopta company had been long established and its good-quality enlargers and Flexaret twin-lens reflex cameras were exported around the world. Italy was responsible for a number of cameras; a few were high-precision coupled rangefinder or single-lens reflex models but it was their elegant and stylish snapshot models which enjoyed very good sales overseas.

Before the war Britain had a number of volume camera makers. The Ensign company, Kodak Ltd, Coronet and Kershaw all made cameras ranging from simple box cameras to roll-film folding cameras, a minority of which had coupled rangefinders. A few small workshop-based producers still made plate cameras from mahogany and brass for professional use. Britain had a few lens makers of international repute; for example, most of the lenses used in Hollywood's film studios were made in England. But no 35 mm cameras had been made in Britain before the war. Kodak, Ensign, Coronet and Kershaw resumed domestic camera making; indeed they had continued to produce optical and photographic equipment during the war for military purposes. But the cameras were mostly the same as, or were developed from, pre-war models.

Photographic magazines expressed the hopes of their readers that Britain's manufacturers would soon be selling precision 35 mm cameras. AGI sold the Agiflex, a civilian version of a camera they had made for the navy during the war; it was a very good copy of a pre-war German roll-film single-lens reflex camera. MPP made the Microcord, a good copy of the German Rolleicord that sold very well. At last a 35 mm camera arrived, the Ilford Advocate, but it had a fixed lens and simple shutter. It sold well until some competition arrived. The Reid, a copy of the Leica camera, and the Ilford Witness were produced, but only in tiny quantities. Wray made an elegant-looking sin-

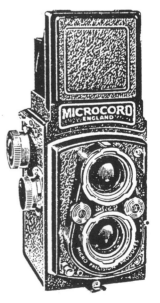

4. *The Microcord, a British camera based on the German Rolleicord.*

5. *The Reid camera.*

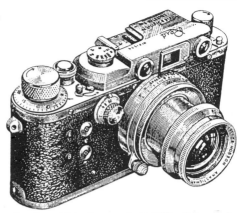

gle-lens reflex camera but its odd design made it difficult to use in everyday photographic practice. Sales were minimal. The only British 35 mm cameras to sell well were the AGI Agima and the ingenious Periflex camera designed and made by Kenneth Corfield.

British-made snapshot cameras sold very well overseas and the makers of better cameras did reasonably well with home sales under the protection of a high tariff and quota restrictions for imported cameras. However, as the quotas began to increase and tariff levels fell, British makers with their outdated designs could no longer compete. By the early 1960s MPP, Ensign, AGI and Corfield had stopped making cameras for the amateur market; only Kodak and Coronet, with their mass-produced snapshot cameras remained.

The partition of Germany meant that the makers of Kodak, Leica, Rolleiflex, Agfa, Franka, Robot, Voigtländer and some Zeiss Ikon cameras were in the Western Zone while in the East were Certo, Exakta, KW, Balda, Welta and Curt Bentzin as well as the important part of Zeiss Ikon where the Contax and Super Ikonta cameras had been made. In the West, conditions were at first so difficult that the camera industry could do no more than try to pick up the pieces. Its patents were seized by the allied powers, who issued licences to makers in Britain, the USA and elsewhere who wished to make use of them. Technical teams visited the plants to record, in minute detail, how production was carried out. Details of these visits, together with copies of working drawings, were available to makers in Britain as BIOS reports from the British Intelligence Objectives Sub-committee. Most factories had been damaged to some extent, although some, such as the Leica factory, had escaped serious destruction. Little by little, despite

11

severe shortages of raw materials and skilled labour, production recommenced. The Marshall Plan pushed millions of dollars into new equipment and facilities in three years and the labour shortage was largely overcome by the influx of skilled workers as refugees from the East. By 1952 60 per cent of camera production went for export and the USA was buying a thousand cameras a day, helping the German industry to export more cameras than it had done before the war.

In East Germany, the long-established companies at first tried, like those in the West, to re-establish production using pre-war designs. Equipment from the Zeiss works at Jena and Dresden was dismantled and shipped to Kiev in the USSR. Over the years the individual companies were largely combined into large co-operatives although some of the pre-war names such as Welta, KW, Certo and Zeiss Ikon continued to be used for a while. A dispute between the West German and East German Zeiss Ikon companies ended with the retention of the name in the Western Zone; the East German concern adopted the trading name of Pentacon. The USSR benefited from the German technology but had produced its own cameras since the 1930s, including a close copy of the Leica camera. Copies of the Ikonta, Super-Ikonta and Contax cameras soon appeared, presumably using the equipment taken from the Zeiss works, but large numbers of Fed and Zorki copies of the Leica were sold to western European countries and were followed by the later Zenith single-lens reflex cameras.

Very few Japanese cameras were advertised in Britain before the war; one or two did appear in the *British Journal Photographic*

6. The Fed C camera.

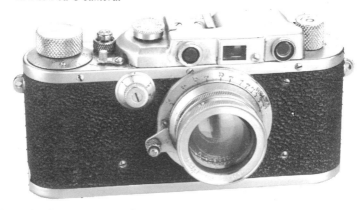

Almanacs in the late 1930s but none was seen for sale in the advertising columns of photographic magazines. But Japan did have a good camera-making industry in the 1930s when it set out to be self-sufficient in all respects, including optical glass and shutter production. Like those in most other countries, the established makers of cameras such as Canon, Konica, Minolta, Olympus and Ricoh tried to restart production after the war, often by assembling cameras from whatever pieces could be found. They were joined by a host of others; some were back-street workshops which made cheap copies of western designs but some, like Nikon, were long-established producers of high-quality lenses and scientific instruments who decided to extend their range of goods for sale.

The occupying Americans gave a great deal of financial and technical support to Japan during a period when there were violent political struggles in the Far East. They also provided a market for its cameras, which were sold to the occupying troops through military shops. Quality standards were imposed on any cameras being offered for export sale and these had to be stamped 'Made in Occupied Japan'. In this way cameras of good quality, although largely copies of older German designs, found their way back to the USA. Manufacturers, such as Nikon and Minolta, who tried to use a smaller format of 24 mm x 32 mm for their early 35 mm cameras were soon made to conform to existing world standards. The Korean War, which started in 1950, brought not only more troops to Japan but American press photographers as well. Press cameras have a hard life; spare parts and additional lenses for Leica and Contax cameras were not available in Japan. The locally made copies, the Canon and Nikon cameras and lenses, were given a trial. The results were so impressive that the word soon reached America that some Japanese cameras were as good and possibly better than their German equivalents. Sales agencies were established in the USA, the formal occupation of Japan was terminated, brand-new designs were developed and the business began of selling cameras to America in large volumes. By the early 1960s the sales of Japanese cameras matched those of Germany.

Until the late 1950s British photographers could only read about these developments; just a few Japanese cameras found their way as second-hand items on to dealers' shelves. Japan's pre-war reputation for making shoddy goods lasted for a long time in Britain. Wallace Heaton, one of the most prestigious camera shops in London, issued an annual sales catalogue called the *Blue Book* after the colour of its cover. When, at last, the importation of Japanese cameras into Britain was allowed, the 1961-2 *Blue Book* carried this notice: 'We are, of course, aware that Japanese cameras have had an extensive build-up in the United States. We have

not accepted this at face value, but decided to include in our *Blue Book* only those instruments which we have been able to test in the comparatively limited time and small numbers in which these instruments have been available on the British market, and which we found to be optically sound and able to stand up, in our opinion, also mechanically, to the requirements expected from each instrument in its respective class.'

2

Snapshot or simple cameras

Snapshot cameras, that is simple cameras which do not require the user to set many controls, had been popular for about fifty years before 1945. By the time war started in Europe in 1939 the box-form and folding bellows cameras outsold all others. In the 1930s they were joined by roll-film cameras made of moulded plastic.

By 1945 most snapshots were still taken on black and white film and prints were made by contact printing; the negative and paper were pressed together against a sheet of glass through which light was passed to make the exposure. Since most snapshooters wanted a reasonable size of contact print they had to start with quite large negatives; the most popular sizes were eight pictures on a 120 or 620 roll film each 6 cm x 9 cm, twelve pictures on a roll of 120 or 620 film to give pictures 6 cm by 6 cm or eight photographs from a roll of 127 film, $1^{5}/_{8}$ inches by $2^{1}/_{2}$ inches (4 cm x 6.5 cm). In the USA some cameras were made after 1945 using the larger 616 film size which was then still popular. The only significant change from pre-war cameras was the inclusion of flash synchronisation, the means of setting off flashbulbs so that they reached the peak of their brilliance when the shutter was fully open.

Box-form or moulded plastic cameras did not need the scarce materials and skilled labour force required to make high-class 35 mm or roll-film models so that both established camera makers and new companies were able start their production soon after the war finished.

Box cameras

The Kodak company was soon back in production in Britain with its famous Brownie box-form cameras. From 1946 they produced a range of Six-20 Brownie cameras: the simplest, the model C, had a control only for instantaneous and time exposures; the model D had a close-up or portrait lens and the model E had, in addition, a yellow filter to make clouds show up better in black and white photographs and contacts for the use of a flash attachment using expendable flashbulbs. They retained their familiar box shape and black leathercloth finish and at first were made only for export.

Coronet Cameras Ltd of Birmingham made a large number of traditional box cameras for many years after the war ended. They were sold under many names such as the F.20, Conway, Ambassador and Super Flash, but they were also made as 'premium offer'

7. (From left) Zeiss Ikon Box-Tengor and Kodak Brownie Model F.

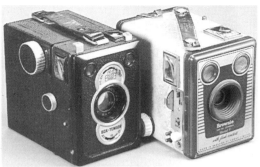

cameras such as 'The Outspan Camera' to be given away in sales promotion schemes by the suppliers of foods or consumer goods. France, like Britain, had to exclude or severely restrict importation of anything but essential goods for a number of years. Coronet arranged with Tiranty for the production and sale of their cameras in France.

As Europe began to recover, its camera makers restarted production. Agfa, Bilora and Zeiss Ikon in Germany, Gevaert in Belgium, Ferrania in Italy and Lumière in France all sold box cameras. Probably the most highly regarded was Zeiss Ikon's Box Tengor camera. It was made of metal with an elegant imitation leather covering and a bright metal trim to enhance the front panel. It had

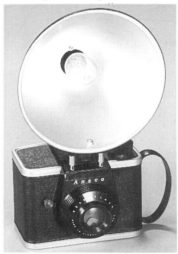

a coated lens of a better quality than that normally fitted to box cameras, three distance settings for the lens, flash synchronisation and a device which prevented the release of the shutter until the film had been wound on. Its price, however, was high. In Britain, in 1952, it cost £7 6s 11d. The imported Agfa SynchroBox camera, which was well made and had a yellow filter, cost £2 13s 0d.

In the USA there were a number of makers of box cameras. Eastman Kodak made their Brownie cameras, includ-

8. Ansco Redi Flash camera with plug-in flashgun, late 1940s.

ing the Target Six-16 for 616 film which gave a picture 6.5 cm x 11 cm. The use of flashbulbs was more popular in the USA than Europe for a number of years. The Spartus Press Camera was made first in 1939 and for some years after the war. It was a conventional box camera with the inclusion, above the body of the camera, of a large reflector and socket for flashbulbs. It was the first camera of any kind to have a built-in flashgun and was very popular. In Europe in 1950 Philips, who were well-known for their flashbulbs, sold a similar camera, but in much smaller quantities. The English company AGI offered the Agiflash camera, a moulded plastic simple camera for use at eye level, which had a built-in flashgun. However, its reflector could be detached, which made it easier to carry when flash was not being used. In the 1950s and early 1960s an increasing number of cheap cameras had built-in flashguns, such as Kodak's Brownie Starflash and Starmite range. Many simple cameras had contacts for the use of a separate flashgun but very often the only gun that would fit was a special one made by the camera manufacturer. In addition to the socket for connecting the electric supply to set off the flashbulb, there were screws, catches or brackets for attaching the gun only to one model of camera or, in some cases, a limited range of cameras. Often the camera, flashgun and a roll or two of film were sold together as an outfit.

Large waist-level finders

Although the traditional box camera was still very popular in the 1940s and 1950s its most serious disadvantage was a poor view-finder. In use the camera had to be held at waist level and the view to be included in the photograph was seen by looking down into a

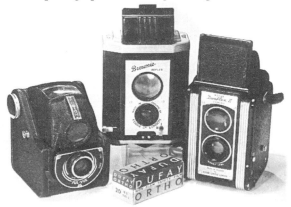

9. (From left) Ensign Ful-Vue, Kodak Brownie Reflex and Duaflex II cameras.

17

small lens, about 20 mm long, set into the side of the camera body. It was not easy to make sure that the camera was level and that heads or feet were not cut off. One way of overcoming the problem was to use a very large viewing lens at the top of the camera although this was suitable only for cameras which took square pictures. In 1939 Ensign introduced their first Ful-Vue camera, which used a viewfinder lens almost as large as the 6 cm x 6 cm negative. When production restarted just after the war it was reissued in an improved form with the top part of the body elegantly curved. It cost £3 1s 10d in 1946 and went on to be sold in large numbers into the 1950s. These easy-to-use large waist-level finders proved to be very popular. Kodak used them for their Brownie Reflex cameras, which took twelve pictures on a roll of 127 film, each 4 cm square, and the larger Kodak Duaflex cameras used 620 film to give twelve 6 cm square negatives. The Brownie Reflex cost £3 11s 8d in 1952 and the Duaflex was £4 6s 0d. Similar cameras by other makers were the Ilford Craftsman, the Gnome Pre-View, the Pucky by Ising, Halina's Prefect and, from the USA, the Ansco Rediflash, the Argus 40 and 75 and the Spartus Full-Vue.

Folding cameras

Although they were relatively cheap and easy to use, box-form cameras were rather large to carry about. Bellows, made of pleated leather, had long been used in cameras which could be folded away for carrying and storage. These cameras, too, were popular for a

10. (From left) Kershaw King Penguin, Kodak Brownie 620 and GB-Kershaw 110 cameras.

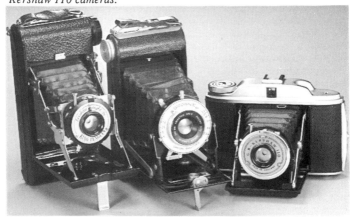

while after 1945 even though they cost a little more than their box-form counterparts. Kershaw's Penguin camera, which had a waist-level finder, cost £5 2s 9d in 1949; the later King Penguin had an eye-level finder. Coronet sold their Clipper and Rapide cameras and in 1952 Kodak's Folding Brownie with a simple lens, but with focusing to 6 feet (1.8 metres), was offered at £5 14s 8d. By 1954 Ensign, the other large-volume camera maker in Britain, sold the Ensign Snapper for £5 10s 8d. Bellows, however, were easily damaged: sharp objects could make holes in them and a carelessly held cigarette could burn a hole. One or two companies made collapsible cameras where the bellows were replaced by tubes. For example, the Photax camera from France was made of moulded plastic with the lens mounted in a large-diameter tube which screwed in and out of the body. The British Wembley Sports of 1950 was made along the same lines at £4 17s 6d with a focusing lens and a three-speed shutter. Both cameras took eight pictures on a roll, each 9 cm by 6 cm. The Gugo, a metal-bodied camera with a pull-out lens tube, and Braun's Paxina camera, with a rectangular-section pull-out tube, both took twelve photographs 6 cm square on 120 film. They cost a little more, between £7 and £8, but they had rather better lenses.

Eye-level cameras

Simple cameras with eye-level viewfinders quickly became very popular in the post-war period. Although some were still made from sheet metal most used the more modern techniques of plastic moulding and the casting of light metal alloys. Many took twelve pictures 6 cm square or eight photographs on a 127 roll; these were still large enough to give contact prints of acceptable size. Some popular eye-level viewfinder cameras taking eight pictures on a 127 roll film were the Kodak Brownie 127 camera, the Bilora Bella and the Ferrania Ibis. In the equally popular 6 cm square size there were the Brownie Cresta, the Agfa Clack and the Isola, many Coronet cameras with names like Victor and Commander, and the Ferrania Ibis 6x6.

Smaller and lighter cameras could be offered if the negative size was smaller still. Purma, who made a sixteen-on-127 camera, pointed out in an advertisement in 1950 that one roll of 127 film and sixteen en-prints (small enlargements from the whole of the negative) cost less than two 120 roll films and sixteen contact prints. When colour print film became available in Britain in the middle 1950s it was also more economical to make small negatives and have them en-printed. For this reason many snapshooters chose cameras taking twelve or sixteen pictures on a 127 roll film. Popular cameras were Kodak's Brownie 44A, the Ilford Sporti 4,

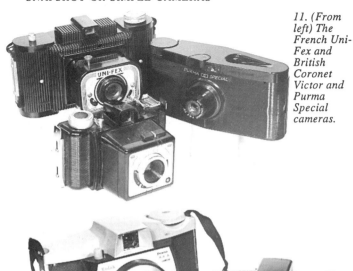

11. (From left) The French Uni-Fex and British Coronet Victor and Purma Special cameras.

12. (From left) Kodak Brownie 44A and Brownie 127 cameras.

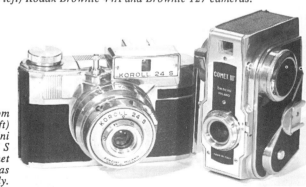

13. (From left) Bencini Koroll 24 S and Comet III cameras from Italy.

20

the Comet cameras, which were imported from Italy by Boots the Chemist, and Bilora's range of Bella cameras.

Kodak had done much to popularise the use of colour photography. At first amateur colour photographs could be made only as colour slides but for the most part films were available only in the 35 mm size. However, Kodak made a small roll film, the Bantam or 828 size, producing eight pictures 28 mm x 40 mm, too small for decent-sized contact prints but ideal for projection as slides. Coronet made some small and cheap cameras to use this size of film. In 1955 Kodak launched the Bantam Colorsnap camera to encourage snapshooters to try their hand at making colour pictures. Shutter speeds and f stops were replaced by a simple dial giving subject type and weather conditions. It was very popular and was followed a couple of years later by a similar camera, the Kodak Colorsnap 35, which used 35 mm film.

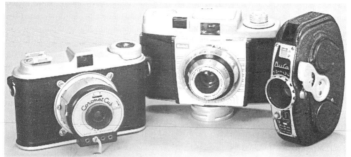

14. Three small-format cameras: (from left) Coronet Cub, Kodak Colorsnap 35 and Durst Duca.

Instant film-loading systems

Although the loading of roll films or 35 mm films caused few problems for the experienced photographer it seemed to worry many snapshooters who took only one or two rolls of film a year. Snapshooters exchanged stories of films that did not wind on properly or tore halfway through, of pictures that overlapped and of films which had been put through a camera a second time. Such experiences, or even the stories of other people's mishaps, were enough to send snapshooters into camera shops or pharmacies to ask the assistant to remove an exposed film and replace it with a fresh one.

By the early 1960s the use of colour print film was growing quickly in popularity but to make it economical small negatives were needed, linked to good-quality developing and en-printing. Old-style box cameras and folding roll-film cameras were not

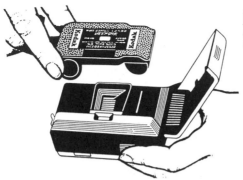

*15. Loading
Kodak's Instamatic
cameras, from a
counter display.*

suitable. What was required was a design taking small negatives
which retained the box camera's ease of use, yet had a film-loading
and wind-on system that was foolproof and prevented double or
blank exposures. Kodak provided the answer with their Instamatic
system, which was launched in the spring of 1963. The heart of the
system was the Kodapak cartridge. Loading could not have been
easier. All that was necessary was to open the camera back, drop in
the Kodapak cartridge (it would go only one way round), close the
back and move the winding lever until it locked. After each picture
was taken the lever was wound until it stopped once again. When
all the film was used up the cartridge was removed from the
camera and sent for processing. Rather than include a mechanical
counter in the body of the camera, Kodak chose to retain a small
window in the back of the Kodapak cartridge in which the photog-
rapher could see the exposure number printed on the film backing.
Although it was no longer necessary to watch for the number as the
film was wound on, it no doubt gave a feeling of confidence to the
user to see that the film had moved as the lever was flicked across.

The Kodapak cartridge, also known by the Kodak film number
126, gave twelve exposures 28 mm square. Kodak launched a
number of Instamatic cameras at Photokina, a major photographic
fair in Cologne, in March 1963 and they went on sale in the United
Kingdom on 1st May 1963. The model 50 had provision for the
addition of a flash-holder, the Instamatic 100 included a pop-up
flashgun and the 300 used a built-in exposure meter to set the
exposure controls automatically. Prices ranged from £2 15s 3d for
the 50 to £20 15s 7d for the 400 model, which was similar to the
300 but had clockwork automatic film wind. A twelve-exposure
black and white film cost 4s 1d; a colour print film, the recently
launched ASA 64 film Kodacolor X, was 9s 1d and colour slides

22

could be taken on Kodachrome X for £1 5s 6d for twelve exposures, processing included.

The camera and its film system were an immediate success. The ease of use was complemented by the world-wide provision by Kodak of supplies and the special equipment for handling the new size to film-processing companies. In time tens of millions of Instamatic cameras were sold. Later Kodak licensed other companies to make cameras and films in the 126 size.

The high sales of Instamatic cameras ensured a good market for Kodak films. Agfa, together with a number of other film-making companies, had been developing their own system for an easy-loading film cartridge since the early 1960s and in June 1964 they announced the availability of their Rapid films and cameras. The Rapid system, which was a development of Agfa's pre-war Karat cartridges, used conventional 35 mm film, which was supplied in a small cylindrical container which at first sight resembled the standard 35 mm film cassette. A short length of film protruded from the cassette; its end had been rounded off and stiffened by embossing. It was placed in the chamber at one end of the camera and an exactly similar, but empty cassette was put into the chamber at the far end. The leading edge of the film was laid across the film gate, the camera was closed and the film winder was turned until it came to a stop. The sprocket wheels, moved by the winder, had engaged in the sprocket holes of the film and pushed it forward into the mouth of the receiving cassette.

Agfa launched a range of Rapid cameras to use the new film

16. Instant loading with Agfa Rapid cameras. The demonstration model is on the right.

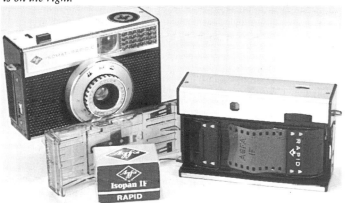

23

cassette. The Agfa Iso-Rapid I camera took sixteen exposures 24 mm square; the mechanical counter returned automatically to zero when the film was removed. A flash coupling was provided in the accessory shoe and the shutter could be used at 1/40th and 1/100th of a second. The camera cost £3 3s 0d. There were more cameras in the range with faster lenses and more shutter speeds at higher prices.

The Rapid system had both advantages and disadvantages over Kodak's Instamatic arrangement. It could be used for different negative sizes, for example 18 mm x 24 mm (twenty-four exposures), 24 mm x 24 mm (sixteen exposures) and the conventional 24 mm x 36 mm (twelve exposures). Indeed Agfa also brought out a Rapid version of their famous Agfa Silette camera when the system was launched. Since normal 35 mm was used, the trade processing houses did not need to re-equip and the film container was much more compact.

But both systems were aimed at the snapshooter who was not concerned with theoretical advantages. Perhaps the snapshooter was worried about the Rapid film not winding on at all, a common fault with 35 mm cameras. It required an act of faith to lay a piece of film across the film track and close the camera without first attaching the film to a take-up spool. Agfa provided dealers with dummy cameras, with transparent backs, so that the potential buyer could watch the film being pushed into its take-up container and be reassured.

The Rapid film was used by other camera and film makers such as Ilford, Fuji, Minolta, Ricoh and Yashica but, although popular for a while, it failed to achieve the success of the 126 or Instamatic film system. In the longer term, and beyond the date limits of this book, the Kodak 110 cartridge and automatic-loading cameras for conventional 35 mm cassettes took over from roll film and 126 cartridges for snapshot cameras.

3
Roll-film folding cameras

By 1939 the folding roll-film camera had become one of the most popular of camera styles and production continued until the early 1940s, when factories were turned over to making war supplies. When peace returned in 1945 the long-established camera makers tried to resume production as quickly as they could, using pre-war designs for which moulds, patterns and tools already existed. However, some companies were able to launch completely new cameras based upon cameras they had made for military use during the hostilities.

At first the only new features seen on post-war folding roll-film cameras were the inclusion of built-in flash-synchronisation sockets and the anti-reflection coating or 'blooming' of lens surfaces. Viewfinders followed the pre-war practice of eye-level frame finders on the cheaper models with optical finders on the more expensive ones. Just a few used the Van Albada suspended frame finders. Many of the 6 cm x 9 cm format models were provided with masks in the film gate to allow the option of reducing the negative size to 6 cm x 6 cm or 4.5 cm x 6 cm to give twelve or sixteen negatives on a 120 or 620 roll of film. Similarly some cameras had the dual formats of 6 cm x 6 cm and 4.5 cm x 6 cm on 20 size film.

Both 120 and 620 film sizes were popular; the only difference lay in the smaller diameter of the core of the 620 reel. As a result 620 camera bodies could be made slightly slimmer than their 120 film counterparts. At one time it seemed that 620 film would become much more popular than 120 and a number of cameras were made which took only that size.

British cameras

In Britain the Kodak factory at Harrow restarted camera production with the Six-20 Brownie cameras which had been designed before the war. They made eight pictures 6 cm x 9 cm on 620 roll film. The more sophisticated Kodak Six-20A cameras were fitted with f6.3 or f4.5 lenses and either four-speed or eight-speed Epsilon shutters. Prices ranged from £14 3s 1d to £22 11s 6d. Between 1946 and 1959 a few million 620 folding cameras were made at Harrow. At first all were exported: home sales started only in 1949. In 1958 Kodak produced, in its factory at Harrow, the Kodak 66 model II (there was no model I), a 6 cm square camera using 620 film. It was fitted with an f6.3 lens and Vario shutter. The model III had the faster f4.5 lens.

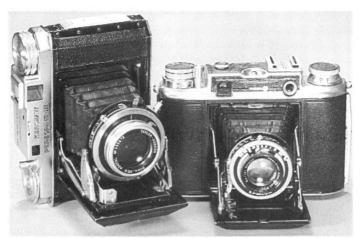

17. (From left) British Kershaw Peregrine III and Ensign Commando cameras, 1940s.

Britain's other large-scale camera maker before the war was Ensign Ltd. Among the first of their post-war cameras to be advertised was the Commando, which, as its name suggests, was based upon a camera made for wartime military use. It took twelve 6 cm x 6 cm or sixteen 4.5 cm x 6 cm pictures and was fitted with an f4.5 Ensar lens in an Epsilon shutter. The shutter was developed and made by Ensign following the design of German shutters. It had a coupled rangefinder and, unusually, focusing was achieved by moving the film backwards and forwards. The film wound to an automatic stop for the square negatives but the red window was needed when the smaller size of negative was selected. It was a sophisticated camera but it was expensive: in 1947 it cost £50 8s 8d.

Other early post-war Ensign cameras were based on pre-war designs such as the Autorange 220 and Ensign Selfix 420. The Autorange had the dual formats of 4.5 cm x 6 cm and 6 cm x 6 cm, an f3.5 or an f4.5 lens and Epsilon shutter, and was also fitted with a coupled rangefinder. The Selfix was a simpler eight-on-120 roll-film camera with an f4.5 Ensar lens and a choice of shutters. With eight speeds it cost £21 13s 8d. Based on the same body, but with a cheaper lens and shutter, the Ensign Ranger was a very popular camera which cost £12 19s 6d. In the late 1940s and early 1950s Ensign brought out their new range of Selfix cameras. These had very well-made bodies, with excellent chrome finish, and most had high-class Ross Xpres lenses. Most of them had reflecting frame viewfinders; when the photographer looked through the view-finder a white frame outlined the field of view, although the frame

was a little dim in some lighting conditions. Three sizes were available: the 820 for 6 cm x 9 cm or 6 cm x 6 cm (with mask); 12-20 for 6 cm x 6 cm and 16-20 for 4.5 cm x 6 cm. Prices ranged from around £16 to £29. The 820 and 12-20 models were also available with uncoupled rangefinders, and coupled rangefinders were fitted to the Autorange 16-20 and the Autorange 820. The Autorange 820 was the most expensive Ensign camera, at £50 7s 0d in 1955

Kershaw had made cameras and other photographic and optical equipment for many years before the war, sold under names such as Apem or Soho or supplied to other companies to sell under their own brand names. At the British Industries Fair in 1947 they showed examples of their Peregrine and Curlew cameras but stated that delivery times could be up to a year away. They were very well-made cameras but they did not sell in the same volume as the Ensign Selfix and Ranger cameras. The Curlew was for 6 cm x 9 cm negatives and the Peregrine for 6 cm square pictures. They were fitted with high-class lenses by Taylor-Hobson and Epsilon or Talykron nine-speed shutters. The most advanced camera was the Peregrine III, which had an f2.8 lens, a coupled rangefinder and an automatic stop mechanism for film winding. In 1949 it cost £58 1s 0d, a very high price for the time. Kershaw, which became part of the Rank Organisation, later made some 6 cm x 6 cm folding cameras of rather cheaper construction which were named after the maximum aperture of their lenses: the Kershaw 110, 450 and 630.

Aeronautical and General Industries Ltd, or AGI for short, had made aerial cameras and many other optical instruments during the war. When the war ended they decided to design cameras for amateur and professional photographers which were to be sold under the name of a subsidiary company, Agilux. The Agifold was a conventional 6 cm x 6 cm camera which could use both 120 and 620 film and had an f4.5 lens. At that time some roll-film folding cameras were still being fitted with tiny waist-level reflecting finders which were mounted to one side of the lens. The user of the Agifold had a choice since an optical eye-level finder and a waist-level finder were placed side by side on the camera body. Both four-speed and eight-speed shutters were offered and the lenses and shutters were designed and made by AGI. The camera was strongly made and rather heavy but it was very popular. It was soon joined by the model II, which featured both an uncoupled rangefinder and an optical exposure meter. In 1952 the eight-speed model I cost £24 0s 0d and the model II £29 17s 6d.

French cameras

The French camera-making industry prospered for many years after the end of the war and it produced a number of roll-film

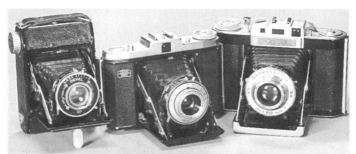

18. (From left) The Dehel from France, Zeiss Ikon Novar and AGI Agifold cameras.

folding cameras. They were amongst the first to be imported into Britain.

Demaria-Lapierre made both 6 cm x 9 cm and 4.5 cm x 6 cm cameras under the name Dehel. The smaller size was quite popular and sold in the USA as the Monte Carlo. The Telka cameras were sold from 1948. They were issued in the same sizes as the Dehel but were more substantially made and were fitted with f3.5 and f4.5 lenses. The top model was the Telka III for 6 cm x 9 cm negatives, with a coupled rangefinder, very good f3.5 lens and Prontor shutter.

Pontiac, who had sold a Bakelite-bodied 6 cm x 9 cm folding camera in the late 1930s, decided to switch to an aluminium body for greater strength. The result was the Bloc-Métal and they managed to keep some production going throughout the war years. It sold in large numbers. Another very popular model was the Kinax by Kinn, also for 6 cm x 9 cm negatives. It was very well-made and was available in a number of models fitted with good lenses and shutters. In the USA the various models were called after French provinces such as Ardennes, Normandy and Alsace.

Royer sold the elegant Royer 6x9 camera fitted with their own shutter and a choice of French-made lenses. A version equipped with a coupled rangefinder of unusual design was the Téléroy. The rangefinder sat directly above the shutter and was operated by rotating the front of the lens itself. Although the camera looked very smart, in practice the rangefinder was not easy to use.

Other roll-film cameras from France were the Drepy by Pierrat and the Lumirex from the famous Lumière company. The 6x9 Drepy, with f4.5 lens and eight-speed shutter, sold in Britain in 1949 for £18 plus tax of £7 16s 0d. Kodak-Pathé made the eight-on-620 Kodak Pliant for a few years until the mid 1950s. The early models looked like pre-war folding Kodak Vollenda cameras from

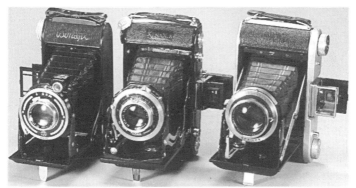

19. (From left) Franka Bonafix, Kinn Kinax II and Ensign Selfix 820 cameras.

Germany and the later ones resembled the British Kodak Six-20. However, they were fitted with French Angénieux and Berthiot lenses.

American cameras

In the USA the two large photographic concerns, Ansco and Kodak, both made folding roll-film cameras after the war was over. The Ansco company had merged with the German company Agfa in 1928 and its first post-war cameras, although made in the United States, bore a strong resemblance to existing Agfa designs. The Viking was a conventional 6 cm x 9 cm camera with f6.3 lens, and the Titan and Speedex were horizontal folding models which took 6 cm square pictures. Later, production took place in Germany.

Agfa's cameras were rebadged for Ansco; the Isolette became the later Speedex and the Billy Record sold in the USA as the Ventura 69.

In 1939 Kodak had launched a couple of conventional folding roll-film cameras which continued in production until the late 1940s. They were the Kodak Monitor and Kodak Vigilant; the Monitor had a smarter finish and a few more features. Both were made in the 616 (6.5 cm x 11 cm) and 620 sizes and were available with lens maximum apertures ranging from f4.5 to f8.8. They were replaced by the Kodak Tourist cameras which used a plastic moulding for the viewfinder housing. The 6 cm x 9 cm Kodak Medalist camera had a rigid body with the lens mounted in a double helical tube. Its high specification included an f3.5 lens, coupled rangefinder and an accessory back for using plates or cut film.

29

America's strong financial position in the later 1940s permitted the free importation of cameras from many countries, including France and Britain. The German industry, which was struggling to re-establish itself, benefited from the strong American demand. So, too, did another country not previously regarded as an exporter of quality cameras – Japan.

Japanese cameras

Although precision miniature cameras were imported from Germany in the 1930s, the demand for roll-film folding cameras, which were then very popular in Japan, had been met to a large extent by domestic production.

When production restarted after the war nearly all the cameras were designed to make 6 cm x 6 cm or 4.5 cm x 6 cm pictures; some took both formats. The sixteen-on-120 cameras often included the word Semi in their names because the negative was only half the size of the one for which the film was originally intended. The names ranged from Apollo to Zenobia. Some of the companies which made them went on to become the giants of the world-wide photographic industry; others prospered for a while but eventually went out of business; some vanished as quickly as they appeared.

The names of Japanese camera companies often changed over the years. For example, the Molta Company became the Chiyoda Optical Company before it adopted the name of its successful line of cameras, the Minolta Camera Company. For simplicity, companies have been referred to by their camera names in the following descriptions.

The Semi Minolta, launched in 1934, had been a popular camera before the war. Production restarted in 1946 with the well-made model IIIA, which had an f3.5 Rokkor lens and shutter speeds from one second to 1/500th second.

20. (From left) Olympus Chrome Six IIIb, Semi-Minolta IIIA and Konica Pearl I cameras.

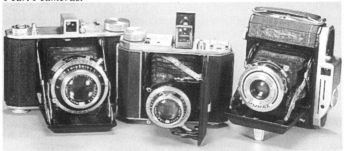

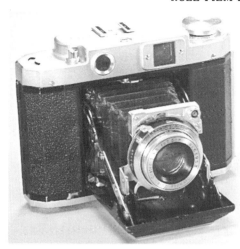

21. Mamiya 6 camera.

In the late 1930s Olympus had made both 4.5 cm x 6 cm and 6 cm x 6 cm folding roll-film cameras which were fitted with Zuiko lenses. One of these, the Olympus Six, was reissued from 1946 and went on, through a number of variations, until the mid 1950s. It was a conventional horizontal bellows camera with either f3.5 or f2.8 Zuiko lenses. One model had a special means of keeping the film under tension in the film gate to improve film flatness. Some late models had rangefinders, both coupled and non-coupled.

Konica, Japan's longest-established camera maker, had great success with the Semi Pearl before the war. It was a vertical sixteen-on-120 camera with a Hexar lens which used a more expensive helical focusing mount to move the whole lens rather than just the front cell. Its post-war successor, for which the prefix Semi was dropped, was further improved with the addition first of a non-coupled and then a coupled rangefinder. The Pearl IV, in the late 1950s, had a frame finder and automatic stop winding. It was a highly regarded camera but users were turning increasingly to 35 mm cameras and roll-film reflexes, so it became the last of the line.

Mamiya had introduced an interesting camera just before the war, the Mamiya Six. It was a horizontal camera for 6 cm square pictures but used the unusual feature of focusing by moving the film back and forth. At first it was manually focused and had both waist- and eye-level finders side by side on the camera body. The post-war model incorporated a coupled rangefinder and the film wound to an automatic stop between exposures. Early post-war

31

cameras had Olympus Zuiko lenses before Mamiya changed over to their own Sekor brand. Like the Olympus and Konica cameras, the Mamiya Six was made with gradual improvements until the late 1950s. It was another very successful camera.

Other post-war cameras were made by companies which subsequently closed down their operations. The Welmy, Proud, Waltax, Petri, Frank and First cameras were well-known folding roll-film cameras in Japan and its export markets in the 1940s and 1950s.

German cameras

In Germany after the war Agfa made two ranges of folding roll-film cameras which were developments of some popular models from the 1930s. The 6 cm x 9 cm models were called Agfa Billy Record or, later, just Record cameras and were made until the late 1950s. They followed the example of many other makers of similar cameras by offering models with a range of lenses from f4.5 to the smallest at f8.8. The Record III was a fine camera with built-in but non-coupled rangefinder which could be bought with Agfa's excellent four-element Solinar lens in a Synchro-Compur shutter.

Agfa's 6 cm square format camera was the Isolette, which was introduced in the late 1930s and was quickly in production again after the war. It proved to be very successful. It was a conventional horizontal-style camera which was light and easy to handle. In Britain only the Agnar and Apotar lens models were allowed to be sold because restrictions limited importation to cheaper cameras, but the camera was sold elsewhere with Agfa's Solinar lens. A model II, with f4.5 Apotar lens and eight-speed Prontor S shutter, cost £20 18s 3d in Britain in 1953. The model III incorporated a non-coupled rangefinder that was easy to use and in the mid 1950s a coupled rangefinder model, the Super Isolette, was sold. It had a much heavier and more robust body than the Isolette; the whole lens moved as it was focused and film wind was automatic.

Voigtländer, too, had enjoyed much success with its pre-war range of Bessa cameras. These were also the starting point for their post-war return to camera making with the Bessa 69, Bessa 66 and rangefinder Bessa II. The 69 and 66 had folding viewfinders and trigger shutter releases in the camera baseboards. By 1951 the 69 had been replaced by the Bessa 1, and the 66 by the Perkeo I and II. Apart from improvements in body design the main changes were the addition of rigid optical viewfinders and accessory shoes. On some models the fine Color-Skopar lens was available in place of the Vaskar. The Bessa II, with Color-Skopar or Color Heliar lenses, had a coupled rangefinder, combined with the viewfinder, which was operated by a knob on the camera top. The Perkeo II, with Color-Skopar lens, had the benefit of film winding to an

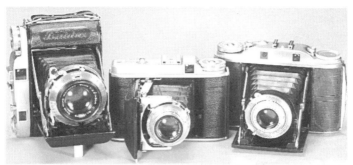

22. (From left) Balda Super Baldax, Voigtländer Perkeo II and Agfa Isolette III cameras.

automatic stop; most were manually focused but a rangefinder version was added to the range.

Zeiss Ikon's range of folding roll-film cameras was held in high esteem in the 1930s; they set the standard to which other makers were compared. To be certain of obtaining the best results with a folding camera it was essential to have the lens and shutter assembly held rigidly in position. Zeiss Ikon achieved this with an excellent design of spring-loaded struts. It is not surprising that so many Japanese designs for folding cameras followed the Zeiss pattern. After the war the company was split between branches in East and West Germany but most of the post-war folding cameras came from the West. Like the other German companies, Zeiss Ikon restarted production using their established designs for Ikonta cameras, their cheaper range of Nettars and the de-luxe Super Ikontas with coupled rangefinders. Zeiss Ikon offered three format sizes: the largest, 6 cm x 9 cm, was still ideal for contact printing; the 4.5 cm x 6 cm and 6 cm square sizes were acceptable, if a little small, for contact prints but were also excellent for making enlargements. A choice of the four-element Tessar lens or the cheaper, but still good, three-element Novar was offered on the Ikontas, with folding optical viewfinders and shutter release interlocked with the film wind to avoid double exposures. The Super Ikontas usually had Tessar lenses, but in the early days some Xenar lenses were fitted.

In the early 1950s Zeiss Ikon introduced their replacement range. The bodies were lighter, the optical viewfinders were built in and the rangefinder optics of the Super-Ikonta were combined with the viewfinder in a housing on the camera body. The new style of Super Ikonta, called the model III, was available only in the 6 cm x 6 cm size; the model IV had a built-in exposure meter.

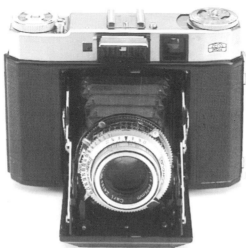

*23. Zeiss Ikon
Super-Ikonta IV
camera.*

The Nettar and Ikonta remained in the 6 cm x 9 cm as well as the 6 cm square models. Both sizes of Ikonta were also offered with non-coupled rangefinders and a version of the 6cm square Nettar, called the Nettax, had an exposure meter alongside the viewfinder. Zeiss, too, stopped making folding roll-film cameras later in the 1950s.

Adox, Balda, Foinix, Franka and Welta were among other German camera makers who sold 6 cm x 9 cm folding roll-film cameras after the war but gradually most of the makers favoured the 6 cm x 6 cm format. To keep the price low, but to aid accurate focusing, non-coupled rangefinders were included in Adox's Rangefinder Golf, the Solida II and III by Franka, the Rangefinder Baldix, the Foinix and the Dacora Royal. Balda was one of the few who made a coupled rangefinder version, the Super Baldax. The rangefinder was combined with the viewfinder, automatic film winding was included and some models had excellent lenses and shutters. It remained on sale into the 1960s. From East Germany came the Certo 6, another coupled rangefinder 6 cm square camera. It, too, had automatic film wind but, unusually for this type of camera a lever was used to advance the film. The lens was an f2.8 Tessar. Franka was one of the few companies to include a built-in exposure meter in a folding camera in their Solida IIL.

Some makers included cheap but impressively large f2.9 lenses in their smaller-format roll-film cameras. The lens quality was not high, but the equipment appealed to photographers who wanted a

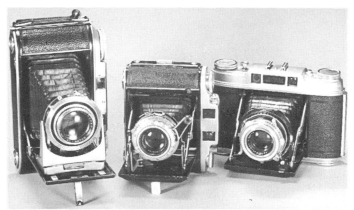

24. (From left) Voigtländer Bessa II, Ensign Autorange 16-20 and Agfa Super Isolette cameras.

camera that looked as though it was something special.

Large-aperture lenses were also a feature of roll-film cameras which used large-diameter pull-out tubes in place of bellows. The top-of-the-range Gloria, Paxina, Goldeck and Dignar models all had f2.9 lenses.

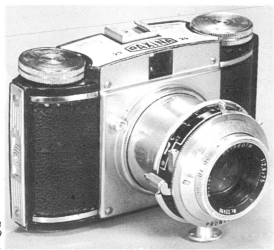

25. Braun Paxina 29 camera.

4

Non-reflex 35 mm and other miniature cameras

In the 1930s the term 'miniature camera' was used for any camera taking pictures of 6 square inches or less. In practice that meant cameras with a negative size of 6 cm x 6 cm and below. After the war the term was more usually applied to cameras with the 24 mm x 36 mm format using 35 mm film and to a few cameras taking pictures of a similar size on roll film. By 1939 the 35 mm film camera was well-established, especially with photographic enthusiasts who carried out their own developing and printing. Germany led the way with the pioneering Leica, introduced in 1925, which was joined in the 1930s by Zeiss Ikon's Contax camera and a number of folding 35 mm cameras such as the Retina, from Kodak, whose relatively low price did much to popularise the miniature camera.

Although a little production took place during the war years, especially in the United States, by 1945 it had become almost impossible to buy a new good-quality 35 mm or other miniature camera. The demand for them was heavy, however, since 35 mm was the ideal size for making colour slides and plenty of government surplus 35 mm black and white film was available at a time when roll films were still in short supply. Since it took a year or two to re-establish regular production in Germany camera makers in other countries such as Britain, Italy, France and the United States took the opportunity of filling the gap. Most ceased production after the German industry had fully recovered and they could not compete with the low price and good quality of Japanese cameras.

The folding bellows 35 mm camera continued its pre-war popularity. But the basic design did not lend itself to the use of interchangeable lenses or exposure automation and by 1960 their production had stopped. High-class cameras, with solid bodies, interchangeable lenses and coupled rangefinders, appealed to the enthusiastic photographer. Their versatility was further enhanced by the addition of built-in exposure meters and better viewfinders but they lost ground during the 1960s to single-lens reflex cameras. The solid-bodied camera with a fixed lens improved continuously; the basic design was ideal for high-volume, low-cost production and the ready inclusion of automatic exposure mechanisms. The fixed-lens models, in time, became the 35 mm compact cameras of the 1960s and beyond – one of the most successful designs of

camera ever produced.

A simple optical viewfinder was fitted to most of the early post-war miniature cameras. When a wide-angle or telephoto lens was fitted to a camera with interchangeable lenses a supplementary viewfinder had to be used. One or two early post-war cameras were fitted with two viewfinders, one for the standard lens and the other for an alternative lens, usually a short telephoto lens of 75 to 90 mm. Both Diax and Akarette cameras included this feature.

When the reflected or suspended frame came into more general use in viewfinders from the mid 1950s it was possible to include the outlines for 35 mm, 50 mm and 90 mm lenses at the same time. Although a number of cameras had this feature users complained of the distracting effect of seeing so many lines in the finder at the same time. Some cameras, following the lead given by the Leica M3, allowed individual frames to be selected. Parallax errors were avoided in some cameras by moving the frame, as the camera was focused.

It was not easy to make a small, robust and accurate selenium-cell exposure meter but by the early 1950s they started to be built into cameras. But within the small dimensions of a miniature camera it was very difficult to make the scales of the meter large

26. (From left) Kodak Retina IIIC, Zeiss Ikon Contessa 35 and Voigtländer Vitessa L cameras, with built-in meters.

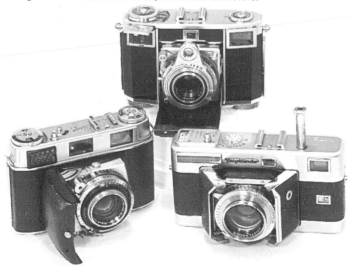

enough to be read at all easily. The arrival of the Exposure Value Shutter simplified things since the user had only to read off a single number and transfer it to the linked diaphragm/shutter speed control. New designs of shutters were introduced where the shutter speed and diaphragm controls were linked directly with the meter; to get the right exposure the photographer had only to alter the f stop number or shutter speed until the meter needle lined up against a mark. Subsequently fully automatic means were developed for setting the exposure controls; the photographer had to do nothing more than press the shutter release. Finally the arrival of the very small and sensitive CdS meter around 1960 made it even easier to make fully automatic exposure cameras.

Although some early post-war miniature cameras were not synchronised for bulb or electronic flash it soon became a standard feature. Various means were tried for winding the film quickly, such as plungers, triggers close to the lens or beneath the base of the camera, and rotating collars around the lens, but the most popular by far was the lever wind, which began to be fitted from the mid 1950s as a standard feature. Rewinding by knob was tedious; the inclusion of a fold-away crank was a boon and the Japanese makers included them in most of their models in the later 1950s.

British cameras

British makers had not produced a 35 mm still camera before the war. In 1947 the Reid camera was shown at the British Industries Fair. It was a close copy of a Leica, made under licence from the Custodian of Enemy Patents. The superb quality of the body and its Taylor Hobson lens encouraged British photographers to think that they would soon be able to buy a locally made camera to match the best in the world and that it was the dawn of a precision camera-making industry in Britain. They were wrong on both counts. The Reid did not reach the market until four years later, at a price of £118 12s 6d, and then only in small quantities. Only a few thousand were made. The Ilford Advocate was a simpler and much more successful camera. Launched in 1949 at £22 11s 6d, it had a diecast lightweight body with an off-white stove-enamel finish. The f4.5 Dallmeyer lens had what was then regarded as the rather short focal length of 35 mm but it gave excellent results. An improved model with an f3.5 lens came out a few years later. Ilford also sponsored the development of a coupled rangefinder camera with a focal plane shutter and interchangeable lenses, the Ilford Witness. The viewfinder and rangefinder were combined, a quarter turn removed the lens and the shutter dial did not spin as the camera was fired. It was a smart camera of advanced design, but

27. British cameras: (from left) Ilford Advocate, AGI Agimatic and Ilford Witness.

only about five hundred were made.

Another successful British 35 mm camera of the 1950s was the Agimatic by Agilux. With a non-coupled rangefinder and provision for an 85 mm telephoto lens it cost £24 17s 6d in 1957. The later Agima, with a coupled rangefinder, was a competitive £19 7s 6d in 1960 but production ceased in the early 1960s in the face of Japanese and German competition.

French cameras

French makers enjoyed some success with their 35 mm cameras. Even during the war some production of the Reyna camera had been possible and after the war well-made, scale focusing cameras came from Alsaphot, OPL, Sem and Royer. Alsaphot made a series of conventional cameras under the name of Maine; the last, the Maine IIIa, had a meter to provide automatic exposure control. The Royer Savoy cameras had f2.8 lenses and shutters speeded to 1/300th second, all of French manufacture; the IIC had a meter built in. Sem made the Sem Kim, a Reyna camera originally made under licence, and the later Orenac, which also had French lenses and shutters. Optique et Precision de Levallois (OPL) were responsible for the very successful Focasport cameras; the Focasport IIC had a rangefinder and coupled exposure meter with the settings visible in the viewfinder. Focasport production continued until the mid 1960s.

The most important French 35 mm camera was the Foca by OPL, which had a focal plane shutter and was on the market within a year or two of the ending of the war. The Standard was equipped with an interchangeable lens with a focal length of 35 mm. The two-star and three-star models had the further advantage of coupled rangefinders, of excellent design, combined with the viewfinder. Alternative lenses were available in focal lengths from 28

mm to 135 mm but only the standard 50 mm lens was coupled to the rangefinder. By 1949 the Universel, which closely resembled the three-star model, was marketed but it had bayonet-mounted lenses which coupled to the rangefinder in all focal lengths. In Britain the Universel sold for just under £100 in 1960 with an f1.9 Oplarex lens.

Some interesting roll-film miniature cameras, such as the Eljy and Gallus Derlux, were also made in France. The Eljy was a pre-war design using roll film to give eight exposures 24 mm x 36 mm. It was a very small camera whose lens and shutter rather dwarfed the body. The Derlux made sixteen photographs on a roll of 127 film, each 3 cm x 4 cm. The focal plane shutter was speeded to 1/500th second and bellows kept the camera light and compact. It was strikingly finished in highly polished aluminium because thin leather covering material was almost impossible to obtain in Europe at the time. The Pontiac, another sixteen-on-127 camera, had a rigid body and f2.9 lens. It, too, had a focal plane shutter and, in place of leather covering, the aluminium surface carried decorative ribbing. By the late 1940s French makers gave up the 3 cm x 4 cm format in favour of 24 mm x 36 mm.

28. French sixteen-on-127 cameras:(from left) Pontiac Lynx and Gallus Derby.

Italian, Czech and Russian cameras

From Italy came the Condor I and II cameras, with coupled rangefinders, the Kristal, which was made to take Leica fitting lenses, and Durst's Automatic, one of the earliest of the fully automatic 35 mm cameras. Czechoslovakia provided the Etareta, a simple fixed-lens camera, and the Opema, which was derived from the Leica standard camera. The Leica camera was also the model for some cameras from the USSR. Production of the Fed camera

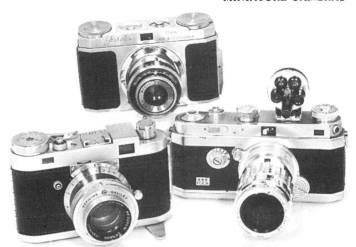

29. (From left) Italian Condor II, Czech Etereta and French Foca cameras.

started in the 1930s in a penal commune. It closely resembled a Leica II camera but was much more crudely finished. It remained in production until the mid 1950s after which it was followed by a series of models which no longer resembled the Leica body design but retained the same screw mount. Improvements included a removable camera back, lever film wind, slow shutter speeds and combined rangefinder and viewfinder. The development of the Zorki camera followed similar lines to the Fed. For about ten years after its introduction in the late 1940s the Zorki was closely modelled on the Leica II camera but from the mid 1950s the body style changed, rangefinder and viewfinder were combined and slow speeds were added, but the Leica thread was retained for the lenses.

The Kiev, from the Soviet Union, was modelled on the Contax, which it resembled very closely indeed. It was assumed that it was made on equipment which had been stripped out of Zeiss Ikon's East German works just after the war. Like the Contax it came in versions with and without an exposure meter and the lens, an f2 Jupiter 8, gave fine results. Alternative bayonet-mounted lenses were available in focal lengths from 28 mm to 135 mm. Fed, Zorki and Kiev cameras were made in very large numbers and, although their finish and engineering standards did not compare well with western and Japanese cameras, their relatively low prices meant that they enjoyed excellent sales throughout western Europe.

American cameras

Popular 35 mm cameras had been made in the United States in the 1930s, when Argus had pioneered the use of moulded plastic for the camera bodies. The Argus C3 had a coupled rangefinder, an f3.5 lens and an ugly rectangular body which earned the camera its nickname of the 'Brick'. It cost $53 in 1950, complete with flash unit and carrying case. With its low price and rugged construction it had very large sales. Argus also made the C4 series with f2.8 lenses, rounded-end bodies and combined viewfinder and coupled rangefinder. These, too, were very popular. Bolsey offered some particularly compact cameras with fixed lenses and coupled rangefinders. Kodak made a range of cameras from the Kodak 35, a pre-war design, through the scale focusing Pony cameras to the elegant Signet with a coupled rangefinder. As the name implies, the Kodak Motormatic cameras of the early 1960s combined clockwork-motor film advance with automatic exposure control.

The Kardon was a close copy of the Leica camera and was commissioned by the military but, since it was ready just as the war ended, it was also sold to the public. The Perfex, Clarus and Detrola 400 cameras all had coupled rangefinders, focal plane shutters and interchangeable lenses, but they were not a match for the Leica, and when it returned they faded away. Graflex, Clarus, Spartus and Ciro made a number of cheaper popular 35 mm cameras.

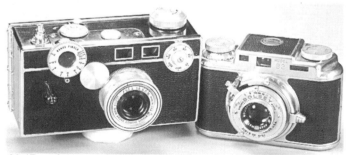

30. (From left) American Argus C3 (the 'Brick') and Bolsey B2 cameras.

Japanese cameras

Much of the success of the post-war Japanese camera industry stemmed from the acceptance in the United States of its better 35 mm cameras. Canon restarted production in 1946 in very difficult conditions. The Canon S II resembled a Leica camera but the rangefinder and viewfinder were combined and the camera body ends were angled rather than round. At first the finish was not very

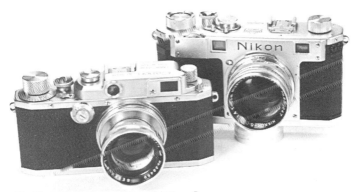

31. (From left) Canon IIB and Nikon S cameras.

good, but it soon improved. Because of the small size of the
viewfinder it was difficult to see the rangefinder spot but by 1949
the model IIB included a means of magnifying the image for
focusing. The Serenar lenses fitted to these cameras had an optical
performance which impressed American users. Slowly the reputa-
tion of the camera began to grow in United States and, once it was
properly promoted, its sales began to increase.

The first Nikon camera was the model I of 1948, which was
based on the German Contax rangefinder camera. Although it had
a similar overall appearance and the same bayonet lens mount and
viewing system, it used a horizontal focal plane shutter with a cloth
blind much like the Leica. It was soon followed by the S and S II
models which made the camera's reputation in the USA. The f1.4
Nikon 50 mm lens was as good as anything made in Germany at
that time.

Canon issued new models based on the same camera body until
in 1956 it brought out a new body shape which was available in
two forms, the VT, which had a fast-action trigger wind in the
camera base, and the L2, which had a similar body but with lever
film wind. The Nikon also went through a number of improve-
ments, which included a greatly improved rangefinder and view-
finder and the addition of lever wind. By the early 1960s both
companies had introduced their single-lens reflex cameras and
phased out their lines of top-class rangefinder models. In 1961
Canon introduced their first popularly priced camera, the Canonet.
It had an excellent f1.9 lens, coupled rangefinder, shutter speeds
up to 1/500th second and automatic exposure control provided by
a selenium cell which encircled the lens. It was an immediate
success, so much so that a new factory had to be built to cope with

43

the demand. The price in Britain was £49 19s 6d. A prototype autofocus camera was demonstrated by Canon in 1963 but it was to be another fifteen years before Konica introduced one commercially.

Some Japanese companies, such as the makers of Konica and Minolta models, had made good cameras for some years before the war but had little or no experience of making 35 mm miniature cameras. Between 1946 and 1949 the first 35 mm Konica, Mamiya, Minolta and Olympus cameras were on the market. Most were scale focusing cameras with fixed lenses, but the Minolta was modelled somewhat on the Leica with a matching screw mount, focal plane shutter and coupled rangefinder. The Leica was copied more or less exactly in the Tanack, Honor, Leotax and Nicca cameras, which sold well until the later 1950s. Yashica took over the Nicca brand from 1958 and went on to be a major Japanese camera company.

32. (From left) Konica I, Minolta 35 and Olympus 35 cameras.

Olympus, Minolta, Konica, Petri, Ricoh and Mamiya all developed their 35 mm cameras, with fixed lenses and blade shutters, into the 1960s. As time passed, lever winds were added, lens apertures increased up to f1.9, exposure meters were built in and automatic exposure control arrived with the Olympus Auto Eye of 1960. The Minolta Super A and Olympus Ace of the late 1950s used interchangeable lenses and blade shutters; this combination was unusual for Japanese cameras. Ricoh put a trigger wind near the base of the lens in its Ricoh 35 camera of 1955 and it remained a popular feature of subsequent models. They continued to promote fast film winding by including a spring-driven motor in the Autoshot of 1964; it later became a feature of many Ricoh cam-

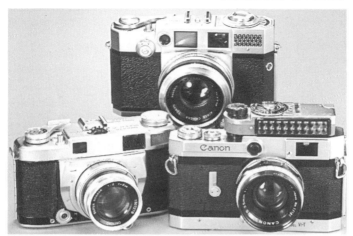

33. (From left) Minolta Super A, Aires 35V and Canon VIT with clip-on meter.

eras. To allow the photographer to switch from colour to black and white in the middle of a roll of film Mamiya in 1957 offered the Magazine camera which had interchangeable film backs.

Minolta tried to emulate the high-speed capabilities of the focal plane shutter when they sold their blade-shuttered A5 camera with a top speed of 1/1000th second. They went further with the V2 and V3, with speeds of 1/2000th and 1/3000th second. At the highest speeds, however, the shutter did not open fully, which restricted

34. (From left) Taron Marquis with early built-in CdS meter and Canon Canonet camera.

the aperture to a maximum of around f8.

There were many other Japanese makers who sold fixed-lens 35 mm cameras during the 1950s and who kept in the forefront of design by regularly introducing new models which included the latest innovations such as bright line finders and built-in meters. However, one by one, they went out of business in later years. Names such as Aires, Beauty, Kallo, Walz, Welmy, Royal and Taron were once well-known to camera buyers. One model of the Taron, the Marquis, was the first 35 mm camera in the world to have a built-in CdS meter.

German cameras

The golden age for German 35 mm cameras was the period from around 1950 until the early 1960s. Competition from the USA and the rest of Europe fell away as a host of new German models reached the market and they were still a match for the rising tide of products from Japan.

One of the appeals of a miniature camera was its small size and none were smaller than the folding bellows 35 mm cameras which were almost a German monopoly after the war. Kodak, who decided to dedicate their German factory to making Retina and Retinette cameras, were back in production by 1946 with the Retina I, without rangefinder, and the model II, which had a coupled rangefinder. There were many improvements over the years until production of the final bellows model, the IIIC, ceased in 1960. The IIIC had a meter and interchangeable front elements

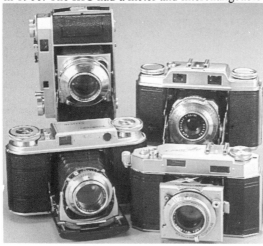

35.
(Clockwise from top left) Retina II, Agfa Super Solinette, Agfa Karat 36 and Voigtländer Vito III cameras.

for 35 mm and 80 mm lenses with corresponding frames in the viewfinder. Balda and Certo sold post-war versions of their pre-war designs such as the Super-Dollina II, the Baldinette and Super Baldinette. They were popular and well-made with good lenses and shutters but Balda later turned to making cameras with solid bodies. They did try a variation of a compact collapsible camera by using a large-diameter telescoping tube in place of bellows in their coupled rangefinder Super Baldina.

Agfa continued with its pre-war range of folding Karat cameras, which used special twelve-exposure Karat cassettes, but introduced the Karat 36, which used a conventional 35 mm cartridge. They were fitted with coupled rangefinders and excellent lenses up to f2. They had a deserved popularity and, like the later Retinas, a means was found of cocking the shutter automatically as the film was wound, a feature usually absent from folding 35 mm cameras. Agfa's Solinette camera and the Super Solinette with coupled rangefinder had drop-down baseboards which protected the lens when the camera was closed. But Agfa, too, stopped making folding 35 mm cameras by the middle 1950s.

Amongst the most powerful of post-war German companies were Zeiss Ikon and Voigtländer, who both brought out folding 35 mm cameras. Voigtländer's Vito was launched as war started. The model II, of 1949, had the Color-Skopar lens, which astonished reviewers with its excellent performance at all apertures. It was further developed as the IIa with a smooth top plate, lever wind and concealed rewind knob. When it was released in 1955 camera makers seemed to be competing with each other to hide the knobs, levers and buttons and leave the top plate as uncluttered as possible. The 1950 Vito III was a quite different camera. It had a coupled rangefinder, a relatively large and very solid body and an f2 Ultron lens, which also received great praise. The Vitessa of 1951 also had an f2 Ultron lens mounted in an unconventional folding camera. On pressing the shutter release button two doors sprang open, carrying with them the lens board. At the same time a tall plunger popped up from the body of the camera by the operator's left hand. By alternately pressing the shutter release and pushing down the plunger pictures could be taken, the film wound on and the shutter cocked in quick succession. In line with the Vitessa's aim for speedy operation, the rewind was fitted with a folding handle, one of the first on any camera.

Zeiss Ikon were rather more conventional in their approach. The Contina and 35 mm Ikonta cameras were like scaled-down versions of the larger roll-film cameras fitted with Novar and Tessar lenses; some models included non-coupled rangefinders. One variation of the Contina, the Contessa 35, was admired since it was

very pleasant to handle. It, too, had a drop-down baseboard and exceptionally rigid struts to keep the lens board from moving. Its coupled rangefinder had rotating wedges like those of the Super-Ikonta mounted above the lens and it was one of the first post-war cameras to include a built-in exposure meter. However, unlike the Retina and Vitessa, the shutter had to be cocked manually.

There were around two dozen German companies which made non-folding or solid-bodied 35 mm cameras in the period and between them they must have made hundreds of different models. Many companies made a range of cameras, starting with basic models with fixed lenses and scale focusing; the better ones had coupled rangefinders and the most advanced allowed the use of interchangeable lenses. To each of these basic designs can be added alternative versions with built-in exposure meters and, from the late 1950s, automatic exposure control. The Vito range from Voigtländer is typical of the better-quality cameras. The Vito B of 1954 had an f3.5 lens and shutter speeds from one second to 1/300th, an optical finder and lever film wind. Within a year or two the lens aperture had grown to f2.8 and a reflecting frame finder was included. By 1957 a version with an exposure meter, the BL, was available at a higher price and in 1958 the Vitomatic offered fast exposure setting with the meter coupled to the exposure controls. A coupled rangefinder was included in the otherwise similar Vitomatic II. The later Vito C had a similar set of variants from which to choose whilst the Dynamatic was like a Vito C but provided exposure automation. The Vitessa T, which had the body and film-winding plunger of the folding Vitessa, had a rigid front in place of bellows to allow the use of interchangeable lenses. Voigtländer were able to exploit a special kind of Compur shutter.

36. (From left) Kodak Retinette Ib, Zeiss Ikon Contina and Voigtländer Vito B cameras.

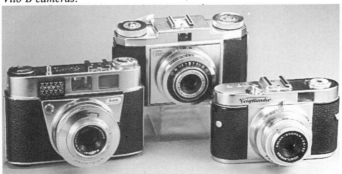

In addition to a bayonet mount, the shutter unit carried the provision for linking lenses to a coupled rangefinder in the camera body. These Compur shutters, and the similar Prontor shutters, made it simple for German makers to provide interchangeable-lens cameras, with coupled rangefinders, at reasonable cost. However, the shutter blades were immediately behind the back of the lens, which made it more difficult to design wide-angle and telephoto lenses for them.

Balda's range under the brand names Baldessa, Baldamatic and Baldessamat, the Regula and Cita cameras from K. G. King and Braun's Paxettes and Super Paxettes and Electromatics mirrored the long list of Voigtländer cameras from simple scale focusing models to the top of the range with coupled rangefinders linked to interchangeable lenses. Other, similar camera ranges of the time included the elegant Arette models from Apparate & Kamerabau, the Lordomat range, all of which had coupled rangefinders and interchangeable lenses, the Ilocas and a few Photavit 35, Finetta, Futura, Regula, Edixa and Frankarette models.

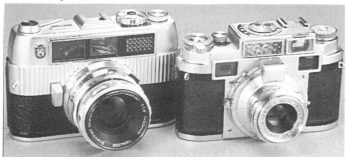

37. (From left) Regula Super and Lordomat cameras.

Agfa enjoyed considerable success with its Silette camera which came on to the market in 1953. It, too, had its coupled rangefinder version, the Super Silette, and later models with meters and various degrees of exposure automation. The Ambi Silette had interchangeable lenses, which clicked home with just a quick twist, and a very bright viewfinder with frames for 35 mm, 50 mm and 90 mm lenses which could be individually selected by sliding a control on the top of the camera. One of the first fully automatic exposure 35 mm cameras was the Optima of 1959. It had a fixed lens and scale focusing but the reliable exposure automation appealed more than a coupled rangefinder or telephoto lens. In just two years Agfa made 500,000 Optima cameras.

Kodak launched the solid-bodied Retinette camera in 1954 and

38. Late 1950s automatic exposure cameras: (from left) Durst Automatica and Agfa Optima.

the Retinette IB arrived in 1959 with a meter built in. By this time Kodak had begun to phase out their folding Retinas in favour of solid-body models. The only solid-body Retina camera to offer interchangeable lenses was the IIIS which had the advantage that each lens, as it was fitted, brought up the appropriate bright frame in the viewfinder. Ilford Ltd did not have the ability to make a range of popular 35 mm cameras of its own. It imported German Dacora cameras, which were badged as the Ilford Sportsman. One of the more interesting models was the Sportsmaster camera, which, in addition to its coupled exposure meter, had four taking buttons on the front of the camera, each corresponding to a different focusing range. As a button was pressed the lens rotated to the appropriate pre-set position for the distance chosen before the shutter fired.

Carl Zeiss, in what was then East Germany, introduced a camera of unusual design in the middle 1950s, the Werra. It took the idea

39. Voigtländer Vitrona with built-in electronic flashgun. The detachable handle carries the batteries.

40. Akarex camera with telephoto lens mounted with its own combined rangefinder and viewfinder.

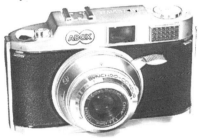

41. Adox 300 camera with a spare film magazine.

of an uncluttered camera body to the limit since the flat top plate housed only the flush-fitting taking button; no knobs were to be seen. The shutter was cocked and the film wound on by twisting a collar around the lens. It had an attractive specification with the renowned Tessar lens and good shutters in all models. Coupled rangefinders and meters came in later models and some had 35 mm and 100 mm alternative lenses as well. It was a very popular range.

Some unusual design features were included in the Akarex, Voigtländer's Vitrona and the Adox 300 cameras. The interchangeable lens of the Akarex did not have separate viewfinders. Each lens came complete coupled with its own combined rangefinder and viewfinder, to which it was attached by a substantial angled

51

support. Not only was this an expensive solution, but the lens assembly, when not in use, was a very difficult shape to store or carry. The 1964 Vitrona, a modified Vito C, was the first camera to have an electronic flashgun built into it but the batteries had to be held in a pistol grip which plugged into the camera base. For a camera that was otherwise a simple scale focusing model, the Adox 300 was a remarkable design. It featured the means of changing films in the middle of a roll by enclosing them in separate magazines, complete with sliding covers and film counters. The whole magazine was dropped into the camera and, as the camera back was locked by twisting a key, the magazine's cover was withdrawn. But the price was high at £61 19s 0d, in 1957, with magazines a further £9 19s 6d each.

By 1939 the top-class Leica and Contax cameras had acquired a reputation for excellence in design and construction that must have been the envy of other makers of quality cameras. Only one other German company, Voigtländer, tried to create a 35 mm range-finder camera, together with a range of lenses and accessories, of a class to match the Leica. At the Photographic Fair in Cologne in 1950 Voigtländer exhibited a prototype camera which attracted a good deal of attention but they had not yet decided what to call it. They ran a competition, which drew over four thousand entries, from which they chose 'Prominent', a name which had been used for another Voigtländer camera in the early 1930s. It reached the market in 1952.

42. Voigtländer Prominent camera with telephoto lens and Turnit viewfinder.

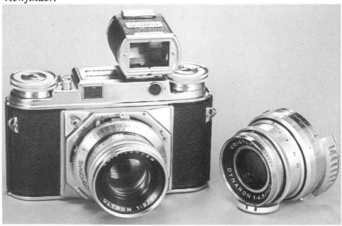

The body of the Prominent was based on the earlier folding Vito III but the bellows were replaced by a solid front to the body. It had a bright viewfinder which was combined with the coupled rangefinder. The focusing knob was placed at the left-hand end of the body, which made it particularly easy to use. The standard lens was an f2 Ultron although a faster f1.5 Nokton was also made. The least successful feature of the camera was the awkward way in which the wide-angle and telephoto lenses were coupled to the rangefinder. At the base of each lens were four large lugs which fitted over external bayonet mounts on the camera body; this made them particularly large and heavy compared with their Contax or Leica counterparts. However, the use of the Compur Rapid shutter was much appreciated at the time since it allowed the use of both flashbulbs and electronic flash up to the fastest shutter speed of 1/500th second. 35 mm and 100 mm alternative lenses were available from the start, together with an excellent auxiliary viewfinder; a 150 mm lens came later but it was not coupled to the rangefinder. A later version, the Prominent II, had a bright line finder with frames for all the focal lengths. Other accessories included a reproduction stand and a reflex housing. But the camera did not match the Leica in versatility, lightness or speed of use. Voigtländer discontinued production by about 1960 and concentrated on its more successful top-class single-lens reflex cameras.

The pre-war Contax camera had been made in Dresden, in what became East Germany, and a few post-war Contax II cameras were made there under very difficult conditions. When the equipment was removed, many of the skilled workpeople migrated to the Western zone, where Zeiss Ikon had re-established production in their other facility at Stuttgart. By 1950 the West German Contax IIa was ready. Although it retained the general appearance and lens mount of the pre-war camera, it was a completely new model. It was smaller and lighter than the Contax II and was delightful to use. It retained the combined rangefinder and viewfinder and the convenient bayonet-mounted lenses which had set the camera apart from the Leica. Post-war lenses were issued in lightweight mounts, although all the earlier lenses could still be used. A second model, the IIIa, was a very similar camera but was fitted with an exposure meter above the viewfinder. Zeiss Ikon, however, unlike most other makers of top-class 35 mm cameras, did not introduce improvements such as lever winds, rewind cranks and parallax-compensated bright line finders. The cameras remained in production until about 1961, when Zeiss Ikon, like Voigtländer, Canon and Nikon, turned away from coupled rangefinder cameras for their top models and concentrated on developing single-lens reflex cameras.

The Leica camera, which had introduced the use of 35 mm film for precision still cameras in 1925, was still leading the field when the Second World War began. Production continued throughout the hostilities, principally for military and scientific use. The factory was not badly damaged and in 1945 the cameras became available for civilian sales once again, at least to those countries, like the USA, whose economies were sound enough to permit such expensive foreign imports. The Leica IIIc, which was made during the war and up to 1950, had a diecast body, focal plane shutter from one second to 1/1000th second, interchangeable screw-mounted lenses, and a separate viewfinder and rangefinder. Flash coupling was not fitted as a standard feature although it could be added by camera mechanics or by the factory. The standard lenses were the f2 Summitar and f3.5 Elmar, which were factory coated. The model IIc, without slow speeds, came out in 1948 and a year later the Ic was issued without rangefinder or viewfinder, principally for use with microscopes and other scientific equipment.

43. Leica IIIf camera and f1.5 Summarit lens.

By 1950 most cameras were synchronised for flash photography, even box cameras. The Leica IIIf brought the marque up to date with the inclusion of internal flash synchronisation. In most other respects the IIIf was similar to the IIIc. IIf and If models were issued a couple of years later.

The increasing challenge from German cameras, such as the Prominent, and from the Japanese Nikon and Canon models, all of which had combined rangefinders and viewfinders, made the Leica camera look a little outdated in the early 1950s. Indeed the IIIf was little different to the IIIa, which had been introduced about fifteen years earlier. But Leitz had the answer in the shape of the Leica M3 camera of 1954. At the time it created a sensation and, at a stroke, it jumped ahead of all the opposition. The camera was a completely

44. Leica M3
camera.

new design: the lenses were bayonet-mounted; a rapid-action lever was used to wind the film; when a fresh film was loaded the frame counter reset itself to zero; the back was made to open completely for easy film loading; and the shutter dial, which no longer spun round during exposure, had a notch to allow it to be coupled to an exposure meter. The standard lens was the recently introduced Summicron f2.0, which set new standards for sharpness and contrast. The viewfinder, at last, was combined with the rangefinder. It gave an outstandingly bright image with a rangefinder spot that was clearly defined and easy to use. The field of view was delineated by a bright frame which moved, as the lens was focused, to provide parallax correction. Separate frames were included for 50 mm, 90 mm and 135 mm lenses. The M2 model of 1956 was similar to the M3 but had viewfinder frames for the most commonly used focal lengths of 35 mm, 50 mm and 90 mm.

Once again the Leica was the best camera in the world. But not all Leica users were happy, especially if they had recently invested in a range of screw-mount lenses. In 1956 Leitz went on to make what became the last of the screw-mount Leica cameras, the IIIg, which was an updated IIIf. The rangefinder and viewfinder were still separate but the finder included parallax-corrected bright frames for 50 mm and 90 mm lenses.

5
Reflex cameras

In a reflex camera a mirror is used to reflect light passing through a lens on to a ground glass screen in order to produce an image. Just one lens is used in a single-lens reflex camera for both viewing and taking the picture; the mirror has to be moved out of the way an instant before exposure takes place. A twin-lens reflex camera uses two lenses which are linked together for focusing. The lower lens is used to take the photograph; the upper one forms the viewing image.

The single-lens reflex design seems to have so many advantages that it might be wondered why the twin-lens variety was used at all. A single-lens camera avoids the expense of a second lens; the camera will be just over half the size of its twin-lens counterpart; parallax error is completely eliminated; depth of field can be seen as the lens is stopped down and, most important of all, alternative wide-angle and telephoto lenses can be used with ease. But early single-lens cameras suffered from a number of shortcomings. Only waist-level finders were available, which were rather small for 35 mm cameras, and the image was reversed from left to right. Before exposure the lens had to be stopped down by hand, which made the view on the screen quite dark. The mirror stayed up after exposure, leaving the screen black and expensive focal plane shutters had to be installed to keep light away from the film until the mirror was safely out of the way.

The twin-lens reflex, despite its bulk, was cheaper to make; it was fitted with readily available blade shutters and the image could be seen continuously up to, and beyond, the moment of exposure. For the single-lens reflex to compete, it needed a bright screen, a mirror which returned very quickly after exposure, a diaphragm which would close automatically to the taking aperture an instant before the shutter was fired and, ideally, eye-level viewing. It took about ten years from 1949 for these improvements to come about, but from the late 1950s, when all of the important features had been brought together in 35 mm single-lens reflex cameras, it was clear that they would soon replace twin-lens reflex cameras and 35 mm coupled rangefinder models as the first choice for the discriminating photographer.

35 mm single-lens reflex cameras
At the start of the war there were only two 35 mm single-lens reflex cameras advertised, the Kine Exakta by Ihagee and the Praktiflex by KW; a camera from the USSR, the Sport, did not seem

to be well-known outside its country of origin. The first two were both made in what was to become East Germany. They were joined by the Alpa camera which had been developed in Switzerland in the early 1940s. All four had waist-level finders and lenses which had to be stopped down by hand. The screen of the Exakta was like a magnifying glass with its lower side ground flat to give a much brighter image than a normal ground glass screen. A rangefinder, coupled to the standard 50 mm lens, was included in the Alpa camera; the reflex screen was used for focusing with wide-angle and telephoto lenses.

In 1949 the Exakta II was shown at the Utrecht photography fair but it had only a better screen magnifier to distinguish it from the pre-war model. At the same fair was something quite new: the Contax S camera from what was still called Zeiss Ikon in Dresden. It had a pentaprism for eye-level viewing and interchangeable lenses in a 42 mm diameter screw-thread mount, a size which later became a world standard. About the same time the Alpa Prisma Reflex camera was fitted with a pentaprism with the eyepiece set at 45 degrees and, in the same year, the Italian Rectaflex camera was launched to considerable acclaim. It, too, had a pentaprism for eye-level viewing but the lenses were fitted by means of an easy-to-use bayonet mount. Best of all, the viewing screen included what was described as a rangefinder with no moving optical or mechanical parts. A small semi-cylindrical lens was fitted below the prism. A

45. The first pentaprism cameras: (from left) the Rectaflex and Zeiss Ikon Contax S.

small bright rectangle was seen in the middle of the finder image. If a vertical subject, like a post, was not in focus, the part in the rectangle was distinctly twisted in comparison with the rest of the image, but lined up exactly when the camera was correctly focused. The camera was beautifully made and a range of lenses from 28 mm to 180 mm was also offered for sale. In Italy the price was the equivalent of £42 10s 0d, but importation into Britain was not allowed in 1949.

46. The British Wrayflex camera.

Mirrors, rather than a prism, were used to give an eye-level finder in the British Wrayflex camera, which was first shown at the British Industries Fair of 1950. Sales started in 1951, when the price was £104 4s 0d. The camera was elegantly styled and had a good f2 lens. The film was advanced and the focal plane shutter wound with a half turn of a folding key in the base of the camera. But it had a non-standard negative size: 24 mm x 32 mm. Although that provided more pictures on a film, the size did not match the mounts for colour slides, a serious disadvantage. Later a 24 mm x 36 mm model was added. The viewfinder image was pretty dark by comparison with the Rectaflex and Contax S even though a magnified central spot did aid focusing. Worse still, the image was laterally reversed for landscape views and upside down when the camera was held vertically. Although it was satisfactory for copying and laboratory use, few were sold. Later in the 1950s a pentaprism was added but by then the camera was hopelessly outdated.

The Exakta camera was greatly improved in 1950 with the introduction of the Varex model which had an interchangeable waist-level finder and pentaprism. The other attractive features of the Exakta were: shutter speeds from 12 seconds to 1/1000th second, a lever wind for the film, a built-in film-cutting knife and a self-timer. These inclusions made the Exakta Varex one of the best cameras of its day. The lens, however, still had to be stopped down by hand but this was made easier by the inclusion of a manual preset device. A red dot or mark was lined up against the chosen stop, focusing was done at full aperture and, just before pressing the shutter release, the photographer flicked a loose-fitting ring around the lens which brought the diaphragm to the preset position. Manual presetting became a common feature on lenses for 35

47. East German cameras: (from left) the Praktica FX2, Praktina IIA and Exakta Varex VX cameras.

mm single-lens reflex cameras throughout the early to mid 1950s. A cheaper and smaller version of the Exakta camera, the Exa, was launched in 1951 with a reduced range of shutter speeds.

The idea of using a reflex system for accurately focusing the camera, combined with an optical viewfinder for lining up the shot, occurred to more than one designer. The Ucaflex of 1951 had a mirror and screen for focusing on just the central part of the picture. The first pressure on the shutter release caused the mirror to fly up and reveal a normal optical finder in which the picture could be composed before further pressure on the button set off the shutter. In England Kenneth Corfield (later Sir Kenneth) designed and built the Periflex camera, which was sold from 1953. A telescopic tube was fitted to the top of the camera, which had a mirror and ground glass screen set at the base and a magnifying lens at the top. The mirror was lowered until it was behind the taking lens. A magnified view of part of the picture was seen at the top of the tube and was used to check for sharpness as the lens was focused. When the tube was released it popped up under spring pressure and the eye was moved to the optical viewfinder before the focal plane shutter was fired. The similarity to the submarine periscope gave the camera its name. The taking lens was inter-changeable and used a Leica screw thread. It was good value at £32 19s 3d with a coated f3.5 Lumar lens. The camera continued until

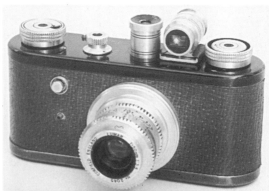

48. An early version of the British Periflex camera.

the early 1960s, with a number of improvements including eye-level focusing and the linking of the lowering of the periscope device to the film wind. The first pressure on the release caused the mirror to retract before the shutter fired.

One of the most influential of the 35 mm single-lens reflex cameras of the 1950s was West German Zeiss Ikon's Contaflex of 1953. In place of the focal plane shutter normally found in single-lens reflex cameras, a special version of the Compur interlens shutter was used. The camera had a fixed pentaprism finder, a Fresnel field lens with a rangefinder spot somewhat similar to the one used in the Rectaflex and a diaphragm which closed down automatically. A hinged metal capping plate prevented light from reaching the film whilst the shutter was open for focusing. When the taking button was pressed a number of things happened

49. (From left) Edixa Reflex Standard and Russian Zenith 3M cameras.

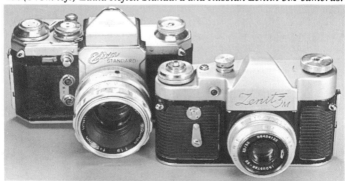

sequentially, but all in a fraction of a second. First the shutter blades closed and the diaphragm blades snapped down to the chosen aperture, the mirror and capping plate moved up and out of the light path and, finally, the shutter opened and then closed again. To the user it sounded like a single clunk. The image in the viewfinder was exceptionally bright but it was possible to focus only by using the rangefinder spot or the narrow band of ground glass which encircled it.

The Contaflex was small, light and indeed no larger than many of the rangefinder cameras then on the market. It sold readily. The camera, with an f2.8 Tessar lens, was priced in Britain at £78 0s 11d in 1955. A year or so later a model II arrived which had a built-in exposure meter. The Contaflex met most of the criteria for a successful single-lens reflex camera but two shortcomings remained: it could not be used with interchangeable lenses and the screen blacked out after the picture had been taken.

50. (From left) Kodak Retina Reflex and Zeiss Ikon Contaflex II cameras.

The East German industry was not standing still. The Contax was renamed the Pentacon after a dispute over trade names and was later improved by the addition of a meter. A refinement of the Praktiflex was sold as the Praktica, a name which grew to be one of the best-known for single-lens reflex cameras. Like the Exakta II, a pentaprism attachment was made to slip inside the hood of the waist-level finder and, later in the 1950s, the pentaprism was built into the body. KW launched a well-made and very versatile camera, the Praktina FX, around 1956. Interchangeable waist-level and pentaprism finders were offered; the lenses fitted by means of a breech lock; the focal plane shutter had speeds from one second to 1/1000th second and a spring-driven winder was available. The lens had a new feature, a semi-automatic diaphragm. The dia-

phragm was first set to the aperture required for taking the picture. A ring was then turned which opened the diaphragm to its widest setting, and at the same it tensioned a spring. When the shutter release was pressed a lever just behind the lens popped forward to strike a pin on the back of the lens mount. The movement of the pin released the spring tension, which snapped the blades of the diaphragm back to the chosen aperture setting just before the shutter opened. In the Praktina IIa of 1957 it was no longer necessary to cock the diaphragm because it returned automatically to full aperture as the film was wound on.

For the mid 1950s Exakta another form of automatic diaphragm was used. The lens itself had a release button which was in line with the one on the camera. The first pressure closed the diaphragm to the aperture chosen: further pressure set off the shutter. A very similar release was used on a new 1955 West German model, the Edixa Reflex from Wirgin. Like the Exakta, it had interchangeable waist and prism finders, a focal plane shutter and lever wind. The Edixa joined the Pentacon and Praktica ranges with its 42 mm lens thread and soon used the pin system for its automatic diaphragm release. Many variations followed of what was to become a very popular camera.

Zeiss Ikon met the challenges posed by the focal plane shuttered cameras by introducing the Contaflex III and IV cameras in 1956. Now the standard lens could be converted to a 35 mm wide-angle lens or an 85 mm telephoto lens by exchanging the front elements. Kodak entered the field in 1956 with the Retina Reflex camera which closely matched the specification of the Contaflex IV. It, too, used a blade shutter, the Synchro Compur; it had interchangeable lens elements for wide-angle and telephoto work and a built-in meter. The 35 mm and 80 mm lens elements were exactly the same as those used with the contemporary rangefinder Retina IIc and IIIc cameras. However, in 1959 Kodak introduced the Retina Reflex S, which had fully interchangeable lenses. The lens blades were now behind rather than between the lens elements. In time lenses from 28 mm to 200 mm were offered, which made the camera more versatile than the Contaflex. Once again, the lenses could be used with a coupled rangefinder camera, the Retina IIIS.

Compur and Prontor reflex shutters had some distinct advantages over focal plane shutters: they always gave even exposures over the whole picture; they were available as ready-made items from experienced shutter makers and they could be used at all speeds with electronic flash. Focal plane shutters had to be assembled as part of the construction of the camera body; the blinds could travel at different speeds giving uneven exposure across the picture, and electronic flash was often limited to 1/25th second, or

51. (From left) Agfa Ambiflex, Kodak Retina IV and Voigtländer Ultramatic cameras.

even slower. Perhaps it is not surprising that blade-shuttered reflex cameras were made by a number of other makers in the later 1950s and 1960s, including some from Japan. Edixa adopted it for one of their cameras, as did Braun in the Paxette reflex. Agfa launched the Colorflex and Ambiflex and Voigtländer the Bessamatic. In France OPL sold the Focaflex and Royer offered the Savoyflex. The Focaflex used an unusual optical system which reduced the size of the prism to the extent that the camera top was as flat as a rangefinder camera.

The Agfa and Voigtländer cameras had exposure meters built in, and the Bessamatic and Ambiflex used bayonet-mounted, fully interchangeable lenses, but the Ambiflex had the further advantage of interchangeable waist-level and prism finders. The Colorflex closely resembled the Ambiflex but the lens was not removable. The meters were coupled to the camera controls so that all that was necessary to give the correct exposure was to adjust the aperture and speed settings until the meter needle lined up with a mark. The Contaflex Super of 1959 and the Voigtländer Ultramatic had the same facility.

In 1959 Zeiss Ikon brought out the Contarex camera, which was designed for the scientific and professional photographer. It was rather large and heavy because of its very solid construction.

Unlike the Contaflex, it had a focal plane shutter and fully inter-changeable lenses. In the earliest version an exposure-meter cell was enclosed in a circular housing above the lens so that it was later dubbed the Cyclops model. Films could be switched over in mid roll through the use of interchangeable backs; a range of accessories was offered and the specially computed lenses have hardly been bettered in later years.

So far all the cameras which have been mentioned have come from Europe and yet it was Japan which later became recognised as the major supplier of such equipment. The first Japanese 35 mm single-lens reflex camera was the Asahiflex of 1952, made by the Asahi Optical Company. It did not seem to threaten other makers with its fixed waist-level finder, focal plane shutter from 1/25th to 1/500th second, f3.5 lens and an optical finder to be used for vertical format shots. However, Asahi made the headlines in 1954 with the Asahiflex IIb camera. It had an excellent instant-return mirror, the first time one had been included in a modern popular camera. The Miranda T of 1955 had a pentaprism, the first from Japan; the second was the Pentax of 1957 and by 1958 both the Miranda and the Pentax had automatic lens diaphragms. In the space of just five years Japan had developed cameras to match those in Europe.

The Japanese trickle became a flood. By 1960 single-lens reflex cameras had been launched carrying the names of Aires, Pentax, Miranda, Konica, Mamiya, Nikon, Petri, Topcon, Yashica, Kowa and Canon. Most of the makers of these cameras offered instant-return mirrors as well as fully automatic diaphragms. Canon,

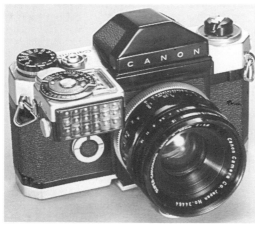

52. *Canon Canonflex R 2000 camera with clip-on selenium-cell meter.*

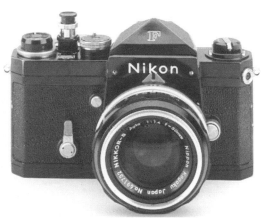

*53. The Nikon
F camera.*

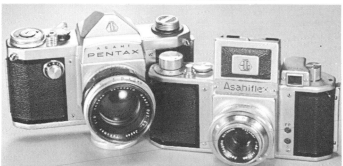

*54. Early Japanese 35 mm single-lens reflex cameras: (from left) the
Asahi Pentax and Asahiflex IIb.*

Nikon, Minolta and Yashica sold add-on meters which coupled to
the shutter speed dials. The Nikon F camera, of 1959, was particu-
larly well-made and was supplied with lenses of the highest qual-
ity. It became the camera of choice of a number of professional
photographers and, because it could be fitted with an electric drive,
it was favoured by press cameramen.

At last all the requirements for an easy-to-use single-lens reflex
camera were in place; all that remained was to couple the exposure
meter to provide fully automatic exposure control. Perhaps a little
surprisingly, two French cameras share the honour. The Focaflex
Automatic and the Savoyflex Automatic both used the trap-needle
method found in many non-reflex cameras of the late 1950s. Many

55. Early automatic exposure models: (from left) the Focaflex Automatic and the Savoyflex Automatic.

more West German manufacturers followed suit and were joined by a number of Japanese cameras, for example Kowa, Mamiya, Aires and Topcon, whose makers, like their European counterparts, found it easier to automate exposure setting with blade rather than with the focal plane shutters. Agfa, who had pioneered automatic exposure cameras, sold the Selectaflex, which had a range of fully interchangeable lenses from 35 mm to 180 mm. One of the most sophisticated of the fully automatic exposure cameras to use a blade shutter was Voigtländer's Ultramatic. It used the interchangeable lenses introduced for the Bessamatic camera, including the world's first zoom lens for a still camera, the f2.8 Zoomar, with a range from 36 mm to 82 mm.

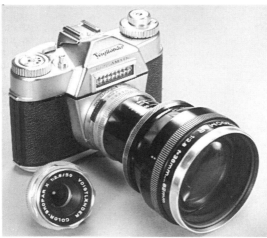

56. Voigtländer Bessamatic camera with the first zoom lens for still cameras, the Zoomar.

In the early 1960s not only were the final improvements made that ensured the success of the single-lens reflex camera but the small, highly sensitive, battery-operated CdS exposure meter was introduced. Add-on CdS meters, which coupled with the shutter controls, were sold by a few makers but the first production model to have the meter built in was the Minolta SR7 of 1962. It was not long before it began to replace the older, selenium-cell meter in reflex cameras. A prototype camera which had a CdS cell behind the lens was shown at Photokina in 1960. It had to be swung into position to take a reading and then moved away again before the picture was taken. It was called the Asahi Spot-Matic.

57. Built-in CdS meters in the Petriflex 7 (left) and Minolta SR-7 cameras.

A production camera, with a through-the-lens meter, was eagerly awaited and it was thought that the first would be the production model of the Spotmatic, but both the Topcon RE-Super and the Alpa 9d beat it to the market in 1963. In a way the Topcon was ahead of its time: it had interchangeable waist and prism finders, both of which could be used with the meter; the lens was bayonet-mounted; an electric film wind could be fitted; and, best of all, metering took place whilst the lens remained at full aperture. Reviews in magazines praised the quality of construction and the high proportion of correctly exposed pictures, including those taken under conditions which posed problems for conventional meters. Thin lines of silvering had been removed from the mirror to let light pass through to it to the meter's sensitive surface which lay below. Since only 7 per cent of silvering was taken away it had no noticeable effect on the screen brightness. When the production Spotmatic did arrive, over a year later, it retained screw-mounted lenses and the meter could be used only with the lens stopped down

to the taking aperture. Despite its name, it did not have spot metering. However, the Spotmatic worked very well and, benefiting from the Pentax's excellent reputation for reliability and good handling, it sold in very large numbers.

Leitz had long been expected to bring out a single-lens reflex but the Leicaflex did not reach the market until 1964. Although it had the usual Leica quality and wonderful lenses there was some disappointment that only an external CdS meter was fitted. However, the viewfinder was the best and brightest then fitted to any camera. It was not long before Zeiss, Leitz and Voigtländer converted their flagship single-lens reflex cameras to through-the-lens metering.

58. Through-the-lens metering cameras: (from left) the Canon Pellix and Topcon RE Super.

Other major Japanese makers also started to bring out their through-the-lens metering cameras. Canon's Pellix used an unconventional approach. The mirror was in the form of a pellicle, a partially silvered thin skin kept taut in a frame. A third of the light from the lens was reflected into the viewfinder; the remaining two-thirds passed directly through the pellicle to the film. When the meter was switched on the cell flipped up, behind the pellicle, and in line with the centre of the lens. Canon soon abandoned this method and joined Alpa, Pentax, Nikon and most other makers by including the cells of the CdS meter in the optics of the pentaprism.

German blade-shuttered single-lens reflex cameras were no match for the Japanese focal plane shutter models. They were not easily developed for use with instant-return mirrors and a wide range of lenses and lasted for only a few more years beyond the last date

covered by this book. Cameras from eastern Europe and the USSR, such as the Zenith and Praktica, which were made in state-subsidised factories, continued to be developed and sold in the West at prices which were low enough to attract buyers who did not want or could not afford the innovations included in the cameras from Japan.

35 mm twin-lens reflex cameras

The 35 mm camera did not lend itself to the twin-lens design, but a few attempts were made. The model C Bolsey camera, a compact, coupled rangefinder model from the USA, had, in addition, a second lens and viewing screen to turn it into a twin-lens reflex camera. The mid-1950s Samocaflex 35 from Japan was a twin-lens camera but retained an optical finder for vertical shots. The best-known 35 mm twin-lens reflex camera is probably the Agfa Flexilette, which arrived around 1960, a time when makers of single-lens reflex cameras had solved most of their design problems. It was little larger than an ordinary camera, had a waist-level finder and very bright screen. Small-diameter f3.5 lenses, one placed immediately above the other, kept the camera compact and light. At £33 18s 0d it enjoyed a modest success.

59. The Agfa Flexilette, a twin-lens reflex camera using 35 mm film.

Roll-film twin-lens reflex cameras

The larger roll-film negative size of 6 cm x 6 cm suited the twin-lens reflex design particularly well. Many photographers found that the relatively large image on the ground glass screen made it easy to achieve a pleasing composition. All twin-lens cameras

share common features. The bodies are rigid box-like structures of two compartments, the lower one for making the pictures and the upper one for viewing. Lenses, closely matched for focal length, are placed one above the other with linked focusing mechanisms. The ground glass screen is provided with a hood to shade it from extraneous light and which can be folded away when not needed.

In the cheaper cameras only the front cells of the lenses move for focusing and their lens mounts take the form of meshed gear wheels; movement of one drives the other. Better cameras have the lenses mounted on a common panel which moves backwards and forwards for focusing. The cheapest film-winding system was to watch for the numbers on the back of the film in the red window. Slightly more expensive cameras used the window for lining up the first exposure, after which an automatic system took over for stopping the film in the right place and for counting the exposures. In the best models the film was brought automatically to the correct position for the first exposure without the need for a red window.

For accurate focusing the grain of the ground glass screen has to be very fine, but the finer the grain the more the screen darkens towards its corners. It helps if the viewing lens has as large an aperture as possible to keep the image bright but in the 1930s some cameras had a screen a little like a magnifying glass with the lower surface ground flat. This gave a significantly brighter image at the expense of a little increase in the size and weight of the camera. Plastics technology had improved so much by the 1940s that a thin

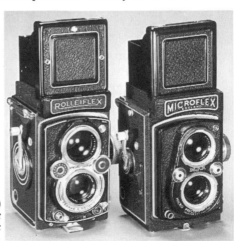

60. (From left) Rolleiflex Automat and Microflex cameras.

plastic sheet could be moulded with fine prismatic concentric rings. These field lenses or Fresnel screens achieved the same effect as the plano-convex screens whilst remaining thin and light.

Although nearly all twin-lens roll-film reflex cameras were made to take 6 cm x 6 cm pictures on 120 or 620 film, a few used 127 film for the smaller 4 cm square size which was popular for colour slides for a few years. Adaptors were also available for using 35 mm film and for making smaller-format pictures on roll film.

A few cameras were made which looked very much like twin-lens reflex models but the top lens was not linked to the taking lens for focusing. One of the most popular cameras of this type was Voigtländer's Brilliant, a pre-war design which was reintroduced after the war with a Vaskar f4.5 lens and Prontor II shutter. It cost £22 11s 6d in 1952. The French Olbia camera and the Italian Elioflex were very similar cameras of the same period.

The immediate post-war Rolleiflex Automat camera, which was very similar to the pre-war version, had an f3.5 lens, automatic film loading, a mirror in the hood for eye-level use and bayonets around each lens for fitting filters. Soon flash synchronisation was included along with factory coating of the lenses. In 1950 a model was introduced with an f2.8 Tessar lens but photographers found its optical qualities fell short of the Rolleiflex's usual impeccable standard. However, the optical standard was restored in the 2.8C model of 1953 with f2.8 Xenotar or Planar lenses. In the 2.8E and 3.5E models an exposure meter was fitted and by the time the F models came out at the end of the 1950s the meter was linked to the shutter and aperture controls. Bright Fresnel screens, provision for alternative formats, improved light baffling and other innovations were included during the 1950s.

As a cheaper alternative, the Rolleiflex T was launched around 1958 with a Tessar lens and the choice of a fitted meter, if required. Kits converted the format to 4 cm x 4 cm and 4 cm x 5.5 cm. For specialist use a few Rolleiflex cameras were made with fixed wide-angle and telephoto lenses around 1960. In the later 1950s, when the use of colour slide films was particularly popular, a small-format model, the Rolleiflex 4x4, was launched which used 127 film for 4 cm x 4 cm colour transparencies, which were then referred to as Super Slides.

The makers of the Rolleiflex joined the automatic exposure bandwagon of the early 1960s with the Rolleimagic camera, a fully automatic exposure twin-lens reflex camera. But users of twin-lens cameras were usually enthusiasts or professionals who wanted to set things for themselves; it was not a design which appealed to the snapshooter. Even a second model, which had manual controls as

61. (From left) Weltaflex, Semflex Automatic and Ikoflex IIa cameras.

well, failed to attract many buyers. The Rolleicord camera was offered as a less expensive alternative to the Rolleiflex. Use of knob film wind, manual shutter cocking and cheaper, but still very good, lenses kept the costs down. For example, in 1960 a Rolleicord Va cost £48 13s 0d, a Rolleiflex T, without meter, was £75 17s 1d and the Rolleiflex E2, with f2.8 Planar lens and meter, was priced at £140 6s 10d. Innovations such as bright screens, internal anti-reflection baffles and alternative film formats were included at the same time as they appeared in the Rolleiflex cameras.

A number of other West German manufacturers also produced twin-lens reflex cameras. Zeiss Ikon came closest to matching the Rolleiflex in quality and ease of use. Their late 1940s Ikoflex 1a was similar to their pre-war model. By 1955 the 1b had a Tessar lens, Fresnel screen and film wind with shutter interlock. In 1956 a meter was included in the 1c but the Favorit lived up to its name since it was a much admired camera. The meter needle was large and easily seen below the ground glass of the viewfinder. Some other German cameras were the Rollop, Delmonta, Rocca and Flexora, which sold in the £30 to £60 price range in the later 1950s. The Rocca and one model of the Rollop had f2.8 lenses, but their very impressive appearance was not matched by the quality of the resulting pictures.

The Weltaflex from East Germany was sold at the popular price of just under £20 in 1960. It was well-made but used the red

62. (From left) Rolleiflex 4x4 and Yashica 44LM cameras.

window for film winding. From Czechoslovakia came the Flexaret cameras with good four-element lenses and radial lever focusing. The best model took 35 mm film with an adapter. The USSR offered the humble Lubitel with geared lenses, a moulded plastic body and just a few shutter speeds. The lens surprised all reviewers because of the good results it gave. In 1965 the camera was just £7 15s 5d. Perhaps its only competition at such a low price was the Halina A1 camera, of 1957, which was made in Hong Kong. It had geared f3.5 lenses, a three-speed shutter and body of rather basic design.

Britain offered the very well-made Microcord camera, which was closely modelled on a Rolleicord design. The Ross Xpres lens was a match for the best similar German lens of the time. The Microcord achieved very good sales in Britain, where, for example it sold for £62 2s 0d in 1956 compared with £72 11s 2d for the Rolleicord V. The Microflex of around 1960 copied the lever wind of the Rolleiflex but could not match its handling qualities. But, not long after its launch, cameras from Germany and Japan became freely available in Britain and the Microflex, which could not compete, was soon taken out of production and sold off for just under £30.

Seven or eight French makers tried their hand with at least one twin-lens model. The Rex, Royflex and Kinaflex sold tolerably well and the Semflex enjoyed excellent sales at home and abroad. The Semflex models ranged from simple versions to the Semflex Otomatic, a model where a lever both wound the film and cocked

the shutter. It had an excellent French lens and shutter and a bright plano-convex screen. The price was very competitive: for example, in 1960 it cost only £32 11s 0d; the Japanese Yashica-Mat, of similar specification, was £38 9s 7d. The Sem Studio camera, which was made for about twenty-five years, had 150 mm lenses for portrait work in professional studios.

American twin-lens reflex cameras sold well in a big home market, with little foreign competition, in the years just after the war. The Kodak Reflex and Argoflex used geared lenses for focusing and the Kodak Reflex II camera had the Ektalite field lens from as early as 1949. Ansco's Automatic Reflex was a very fine camera with an elegant and well-engineered body, lever film wind and excellent lenses. It cost $195 in 1952. The Ciroflex was robust and built on similar lines to the Rolleicord camera. It was the first all-metal twin-lens camera made in the United States, where, over the years, it sold in large quantities with models ranging from A to F.

Easily the largest number of different models of twin-lens cameras came from post-war Japan; over 250 have been listed from at least fifty different makers. As early as December 1946 the *Miniature Camera* magazine had managed to borrow one, the Rollei Konter, which they described in an article entitled 'Japan can fake it'. It was typical of the many cam-
eras which were assembled in back-street workshops for sale to the occupying forces in the early years of post-war camera making in Japan. For a while the existence of these poorer-quality cameras endangered the hoped-for growth in the sales from manufacturers who were determined to raise quality standards. During the 1950s a number of makers produced reasonably good cameras such as the Aires Reflex, Beautyflex, Elmoflex, Walzflex, Primoflex and Topcoflex but these faded away later in the 1950s. Konica, Olympus and Petri tried a model or two but were better known for their 35 mm and folding roll-film cameras. Kowa's first camera was the Kalloflex, a well-made cam-

63. Kowa Kalloflex camera.

74

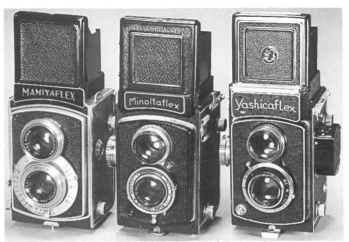

64. (From left) Mamiyaflex, Minoltaflex and Yashicaflex cameras.

era resembling a Rolleiflex but with a plano-convex screen. To improve the speed of handling, the large-diameter focusing knob and the handle for winding the film were mounted coaxially on the right side of the body.

Yashica, Minolta, Ricoh and Mamiya were probably the best-known of the Japanese makers of twin-lens reflex cameras. The Yashicaflex used a knob for winding the film and one of the early models, the Yashicaflex S of 1954, was the first Japanese camera to have a built-in selenium-cell exposure meter. The Yashica-Mat, which was made from 1957, went on to become one of the most popular twin-lens cameras from any maker. In appearance it closely resembled the Rolleiflex Automat camera, and its Yashinon lenses gave very sharp pictures. As its name suggests, the Yashica 635 could also be used with 35 mm film. Yashica also made a popular line of 4 cm square cameras after the successful launch of the Rolleiflex 4x4. Ricoh was one of the few Japanese makers to have made a twin-lens model before the war. Their post-war Ricohflex cameras started in 1950 with a rather cheap model with the taking and viewing lenses geared together. Although cheap, the cameras worked well and were popular with their export customers. The later Diacord cameras were better made, with the lenses on a common panel which was moved, for focusing, by means of a radial lever. The Ricoh Auto 66 camera of 1959 was a semi-automatic exposure camera along the lines of the Rolleimagic.

Minolta had made the first Japanese twin-lens camera before the

war, the Minoltaflex. It was a copy of the Rolleicord, with a film-winding knob. In 1955 the first Autocord appeared, with radial lever focusing and a lever which wound the film and cocked the shutter. It was the first in a long line of Autocord cameras; later examples were available with exposure meters and masks for smaller formats. Many photographers felt that the handling qualities of the Autocord came close to those of the Rolleiflex and the Rokkor lens was excellent.

The first Mamiya twin-lens reflex camera, the Mamiya Junior, came on to the market as early as 1948. Once again a Japanese maker chose to link the viewing and taking lenses by gearing them together. Further, improved models were made until the middle 1950s. However, in 1956 Mamiya tried a different approach to twin-lens reflex design with their Mamiyaflex C (Professional). The lens panel, which was joined by bellows to the body of the camera, moved forwards and backwards on a track which allowed a much greater travel than was possible with conventional designs. This allowed the camera to accept pairs of viewing and taking lenses with longer than normal focal lengths. Each taking lens was fitted into its own shutter and mounted, with the viewing lens, on a panel which could be fitted to the camera in a matter of seconds. The Mamiyaflex C camera found ready acceptance by professional photographers since it was ideal for fashion and portrait work.

Roll-film single-lens reflex cameras

In comparison with the dozens of different twin-lens roll-film reflex cameras which were made after the war there was just a handful of single-lens cameras. With few exceptions, they took twelve exposures, each 6 cm square, on 120 size roll film. The pre-war Reflex Korelle camera was developed as an improved model, the Meister or Master Korelle, around 1950. It had a focal plane shutter and interchangeable screw-mounted lenses. Because the film ran horizontally the film spool holders projected from either side of the almost cubical, main body of the camera. A lever at the right-hand end wound both the film and the shutter ready for the next picture.

The British Agiflex camera, which was sold from 1948, resembled the Reflex Korelle camera even more closely since the lever wind remained at the left-hand side of the camera. It was based on a camera called the ARL, commissioned for wartime use by the Admiralty. The first model had bayonet-mounted, interchangeable lenses and a focal plane shutter with speeds between 1/25th and 1/500th second. The model II of 1949 had a larger bayonet mount, flash synchronisation and slow speeds down to 2 seconds. The model III of 1954 had further improvements, including a plano-

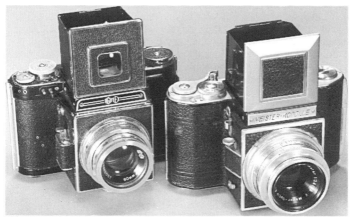

65. (From left) AGI Agiflex II and Meister Korelle cameras.

convex bright screen and a spring-raised mirror. By now telephoto lenses of up to 300 mm were available. The Agiflex III camera cost £95 in 1960 with an f2.8 standard lens.

Another camera to resemble the Reflex Korelle was the East German Praktisix camera, which came from the same maker as the 35 mm Praktina camera around 1956. It used a very similar automatic mechanism where a mechanical linkage inside the camera tapped a pin behind the lens to close the diaphragm from its wide-open setting to the taking aperture. It had a bright screen, lever film wind and the waist-level hood could be exchanged for a pentaprism finder. The focal plane shutter had speeds from 1 second to 1/1000th second and alternative lenses were available from a wide-angle lens of 65 mm to a long telephoto lens of 500 mm. It was a popular camera, in demand by both serious amateur and professional users. In 1960 the price was a very reasonable £155 2s 11d.

A further camera which continued almost unchanged from its pre-war model was the Primar Reflex, also called the Primarflex. In this camera the film ran vertically, which gave it a more box-like appearance. The standard Tessar or Trioplan lenses were interchangeable with both wide-angle and telephoto lenses. Although a prism finder was available the Primarflex was not developed into a modern reflex camera.

The Japanese Fujita 66 camera of 1956 also had an almost cubical body, a focal plane shutter up to 1/500th second and screw-mounted, interchangeable wide-angle and telephoto lenses. By 1960 an instant-return mirror was fitted. At £76, with an f3.5 lens it

was very good value and all the lenses had a reputation for good optical quality. The camera was sold as the Kalimar Six Sixty in some export markets. Japan also provided a 4 cm x 4 cm single-lens reflex, the Komaflex S, around 1960. It took twelve exposures on a roll of 127 film. The standard 65 mm f2.8 lens was not interchangeable but it had add-on lens attachments which altered its focal length to 47 mm and 97 mm. The camera alone cost £41 12s 6d; with the lens attachments as well the price was £55 19s 11d.

One of the most highly regarded cameras of the post-war period is the Swedish Hasselblad, which was launched in 1948. The camera body, which was practically cubical, was fitted with a thin, all-metal focal plane shutter with speeds between one second and 1/1600th second. The lens, an f2.8 Ektar, was removed with a quick twist and could be replaced by one of a range of lenses. From the start it benefited from the recently introduced Ektalite field lens, which gave a bright image to the corners of the viewing screen. For the first time in a 6 cm x 6 cm single-lens reflex the film was held in a detachable magazine which allowed the user to change from colour to black and white film in the middle of a roll without wasting a frame. The Hasselblad was warmly welcomed by professional photographers who could afford the price of $548 in the USA. It was not, at that time, available in Britain. There were problems with achieving such a high top speed with the shutter, so in 1952 a new model came out with a reduced speed of 1/1000th second. This was called the 1000F, the first model then became known as the 1600F.

The Hasselblad 500C came out in 1957. It closely resembled the 1000F and retained most of its features but in place of the focal plane shutter each lens was fitted with a reflex version of the Compur shutter. Like the similar shutter in the 35 mm Contaflex camera, the blades remained open for focusing, but on pressing the release button they closed, opened again to make the exposure and closed again all in a fraction of a second. The lenses,

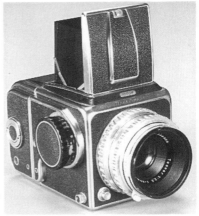

66. Hasselblad 1000F camera.

too, now had fully automatic diaphragms and the shutter was synchronised for electronic flash up to its maximum speed of 1/500th second. The standard lens was the superb f2.8 Planar and a series of alternative focal length lenses was available from 60 mm up to 500 mm. In 1960 the camera cost £273 1s 3d with the standard lens and one magazine.

At first sight the Japanese Bronica camera of 1959 looks like a copy of the Hasselblad. The body shape, waist-level finder hood and detachable film magazine do bear a strong resemblance to the Swedish camera. But the Bronica had some interesting, and quite different, design features. In a single-lens reflex camera it is not normally possible to use a lens which protrudes into the body of the camera since it would impede the mirror as it flies up. In the Bronica the mirror was made to move down towards the base of the camera. This allowed the body to accept wide-angle lenses of conventional design. The Bronica was equipped with Nikkor lenses of superb quality and it had a focal plane shutter with a long range of shutter speeds. Its price was only a little lower than the Hasselblad at £234 17s 1d.

6
Half-frame and subminiature cameras

Throughout most of the 1930s cameras up to 6 cm x 6 cm square were defined as 'miniature cameras' but gradually the term became restricted to those taking the 24 mm x 36 mm format. After the war any cameras which used a smaller format were usually called 'subminiature cameras'. However, the format size 18 mm x 24 mm, which was very popular in the 1960s, came to be known as half-frame or single-frame.

In the 1930s a number of tiny cameras were made which used paper-backed roll films, usually 16 mm in width, such as the Coronet Midget, the Ulca and the Merlin. Although they could take pictures, they were little more than toy or novelty cameras. The Minifex, however, was a high-quality camera using 16 mm film but the most influential of the pre-war subminiature cameras was the Minox, which was first made in Latvia. Several thousand Minox cameras were sold until Latvia was overrun during the war. More were made under Russian control until production restarted in Germany after the war. Its basic design was so well thought out that it remained practically unchanged for half a century.

67. Minox B camera.

Roll-film subminiature cameras

The cheap novelty cameras taking tiny rolls of film made a return after the war. The Coronet Cameo dates from 1947; the Petie and Petitax were made by Kunik in Germany and Japanese makers flooded the market with very cheap cameras which, although sold under about sixty different names, were all very similar. They looked like tiny versions of 35 mm solid-body cameras with direct

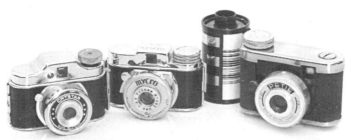

68. (From left) Crystar (Hit type), Mycro IIIA and Petie cameras.

vision viewfinders and a taking lever which projected from the side of the shutter. Many of the earlier ones were called Hit, a name which later became a convenient way to describe the whole group of similar cameras even if the others had names such as Arrow, Crystar, Miracle and Peace. There were other cameras which resemble the Hit but were more substantially made and fitted with anastigmat lenses. Some early examples were the Tone, Rubina and Mycro. The Mycro was introduced in Japan around 1938 and after the war sold in reasonable numbers as the Mycro IIIA.

The Minox

Little bigger than a man's middle finger, the Minox used 9.5 mm wide film in a double-ended cassette comprising two tiny drums with a central bridging strip. The film was supplied loaded into one drum and joined across the bridge to a take-up spool in the other. The user had only to drop the cassette into the camera and pull one end of the camera in and out a couple of times to be ready to take pictures. It was the pattern for many post-war film loading systems. The 1948 Minox A was like its pre-war version but it was lighter and it had a better lens. Some ten years later an exposure meter was built into the Minox B with only a small increase in the camera's length. A complete range of developing, enlarging and projecting equipment was sold and a first-class commercial processing service was available. These factors, combined with the widespread availability of the special films, ensured the Minox's success.

16 mm subminiature cameras

One of the first of the post-war Japanese subminiature cameras was the Steky. It used 16 mm film in tiny cassettes which could be loaded by the user. It was like a small rectangular box with the lens fitted into the longer, narrow side. The quality of the lens, shutter and general construction were sufficiently good to ensure that

sharp negatives could be made. The lens could be unscrewed and replaced by a telephoto lens. The Steky was very popular and went through a number of improvements. It was developed further as the Golden Ricoh or Ricoh 16, which, with its rounded ends and lever wind, looked like a miniaturised version of the 35 mm cameras of the time. The Mikroma, also looking like a conventional camera on a reduced scale, was issued in Czechoslovakia shortly after the war. Small cassettes of 16 mm film were used and the camera had a fine f3.5 lens. The later Mikroma II, usually covered in green leather, had shutter speeds from 1/5th to 1/400th of a second. It became a very popular camera and sold in Britain in 1960 for £16 6s 0d. The German Goldeck 16 camera, of the late 1950s, is large enough to be mistaken for a compact full-frame 35 mm camera but it took 10 mm x 14 mm pictures on 16 mm film, a format which was frequently used for subminiature cameras. The standard lens could be replaced by a telephoto. The Super model with f2.8 lens and nine-speed Prontor shutter cost £31 17s 0d in 1960.

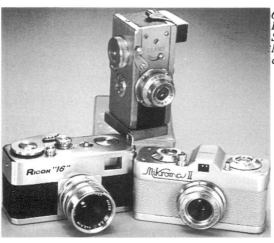

69. (From left) Ricoh '16', Steky and Mikroma II cameras.

Some solid but inexpensive subminiature cameras were made in the USA around 1950. The Minute 16 and the Tynar each sold for about $8 and looked rather like small versions of amateur cine cameras with folding frame viewfinders. The Micro 16 was rectangular in shape and was available in colours as well as black. All of these cameras had modest lens apertures from f6.3 to f8 and simple shutters.

A number of other subminiature cameras followed the general

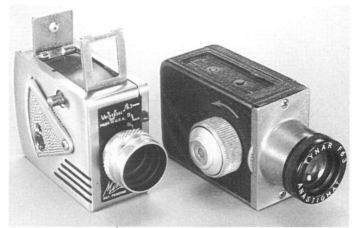

70. (From left) American Minute 16 and Tynar cameras.

shape of the Minox, but none was as small. They were rectangular, perhaps with their ends rounded off to some extent, and about 20-25 mm thick. Popular cameras of this shape were made in Japan by Mamiya, Minolta and Yashica and in Germany by Rollei and Edixa. Mamiya started to make the Mamiya 16 while Japan was

71. (From left) Yashica-16, Mamiya 16 EE and Mamiya Super 16 cameras.

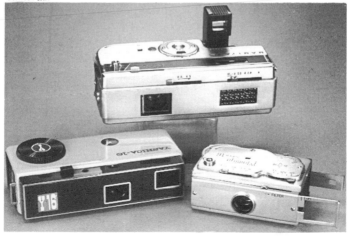

still under occupation. It was well-specified with focusing mount, multi-speed shutter and good lens. The finder comprised two frames which pulled out from the body. Later a revised version was sold, the Mamiya 16 Automatic, with an exposure meter built in. Mamiya used their own plastic double-ended cassette for the 16 mm film. The cameras remained on the market into the 1960s.

Probably the best-selling Japanese subminiature camera was the Minolta 16. This, too, used film in a double-ended cassette which became very widely available and remained in production after the other Japanese companies had stopped making their 16 mm brands. To advance the film on the first models, the camera end had to be pulled out and then pushed in, Minox fashion. The sharp f3.5 Rokkor lens gave good results but supplementary lenses had to be used for close focusing. Later models used a thumb wheel for film advance and were made in a range from a simple camera with weather symbols for setting the exposure controls, the Model 16P which cost £12 5s 11d in 1965, through to the 16EE-II, which used a CdS meter to give automatic control of exposure at a price of £32 10s 9d. In the USSR a camera almost exactly similar to the early Minolta 16 was made under the name Kiev 30 or Kiev-Vega. A quite different film cassette was used by Yashica for their 16 mm camera. Unlike the single metal and the double-ended plastic versions of other makers, the Yashica cassette was complex and impossible to load by hand. For enthusiasts a loading machine was supplied. However, the cassette was very easy to use; it simply plugged into one end of the camera; there was no need to open the camera in any way.

The Rollei 16 camera came rather late into the field in the early 1960s; possibly the makers were impressed by the success of the Minolta camera. The Rollei was beautifully made with a fine Tessar lens, shutter speeds up to 1/500th of a second and fully automatic control of exposure. It used single perforated 16 mm film in single plastic cartridges into which the film had to be rewound after the last exposure. The format size was comparatively large for a subminiature camera at 12 mm x 17 mm, which helped to give first-class postcard-size enlargements. The viewfinder assembly, which was pulled out of the body before use, was also used, push-pull fashion, for film winding. It gave a superb image and had markings for the field of view of the accessory telephoto and wide-angle lenses which could be attached to the bayonet mount around the lens.

Edixa, too, enjoyed good sales with its excellent Edixa 16S camera. It used the same cassettes as the Rollei, a rare example of standardisation of subminiature film systems. It focused to 50 cm, had a very good finder, and a separate exposure meter could be

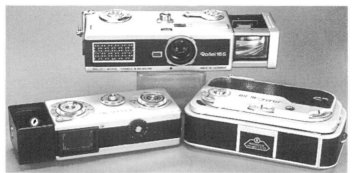

72. (From left) Edixa 16 with plug-in meter, Rollei 16S and Mec 16SB with through-the-lens metering.

plugged into the side of the camera to couple with the diaphragm and speed controls. The camera was sufficiently popular for Edixa to buy the Franka camera works to provide capacity for its production. It was much cheaper than the Rollei at £23 1s 3d in 1965, with a further £8 9s 6d for the meter; the Rollei 16 cost £76 17s 4d.

Feinwerk Technik seem to have made only one camera, the Mec-16, which came out in the late 1950s. It used single cassettes of its own design for 16 mm film. Their second model, the Mec-16SB, was the world's first through-the-lens metering camera. It was beautifully made with an impressive f2 Heligon lens and focal plane shutter. Just in front of the shutter was the cell of a selenium meter which read the light coming through the lens; shutter speeds or the lens diaphragm were altered to balance a needle in a small window. The first pressure on the release caused the selenium cell to flip out of the way before the shutter opened. A slot was provided in the optical path so that filters could be slid in place. In that way the meter automatically compensated for the reduction in light intensity from, say, a yellow filter. The price was £48 19s 10d in 1960.

The focal length of most of the lenses used in subminiature cameras was so short that the depth of field, even at large apertures, was sufficient to assure sharp pictures just with scale focusing. However, a few cameras did come with sophisticated focusing aids. Probably the finest of 16 mm subminiature cameras was the Italian Ga-Mi 16 which had not only a coupled rangefinder but an f1.9 lens, shutter speeds from half a second to 1/1000th second, an extinction meter and a spring film wind for three exposures. Perhaps it is not surprising that it was a little larger and heavier than other subminiature cameras. It was also amongst the most expen-

sive: in 1964 the price in Britain was £175. Another rather large 16 mm camera also had help with accurate focusing, in this case by means of a ground glass screen. The Minicord was made in Austria by C. P. Goerz in the 1950s. It took pictures just 10 mm square. Not only was it a twin-lens reflex, with the viewing and taking lens geared together, but the viewfinder was fitted with a pentaprism to a give bright, right-way-round image, at eye level, for framing and focusing. The camera had a handy fold-down grip and very fast film wind, which made it particularly easy to use. The shutter, with speeds up to 1/400th second, was almost silent. The owner could buy an accessory piece of equipment which converted the camera into an enlarger for prints up to $3^1/2$ inches (9 cm) square. At £49 5s 9d it attracted quite a few buyers.

Surprisingly it was the Russian camera makers who tried the idea of a 16 mm single-lens reflex camera, the Narciss. It was a scaled-down, single-lens reflex camera with a focal plane shutter, just like its bigger, 35 mm brothers, and it had a detachable pentaprism. Naturally the lens could be removed so that a close-up tube could be fitted or longer focal length lenses put in its place. This was made very easy for the user since an accessory kit, supplied with the camera, included an adaptor to allow the use of lenses with Leica screw threads, a mount then common on 35 mm cameras of Russian origin. It seems that not too many Narciss

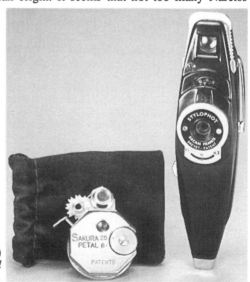

73. (From left) Petal and Stylophot cameras.

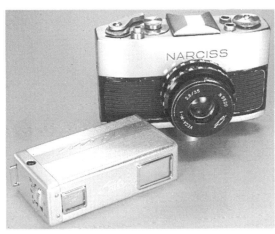

74. (From left) Russian Vega and Narciss cameras.

cameras were made, which is a pity; it was a most attractive design.

Other subminiature sizes

Some subminiature cameras used a circle or disc of film which was rotated between exposures. But, to keep the camera small, the size of the pictures was minute. The rare Steineck ABC camera of 1949 caused something of a stir when it was announced. It was shaped and worn like a man's wristwatch but the face carried the lens and camera controls. The image size was a minute 3 mm x 4 mm but satisfactory enlargements up to 6 cm x 9 cm were claimed. Just over an inch in diameter, the Petal camera of the late 1940s also used a disc of film to give six round pictures. No doubt the novelty value of these cameras was much greater than their picture-taking abilities. The same is probably true of the French Stylophot, which looked like a rather fat fountain pen, complete with clip for holding it inside a pocket. It used 16 mm film and two versions were available, one at £5 19s 6d in 1960 with an f6.3 lens, and a rarer model with an f3.5 anastigmat lens, costing £10 19s 6d.

35 mm subminiature cameras

The Tessina was a unique camera. It was smaller than some 16 mm still cameras but used 35 mm film. It was a twin-lens reflex yet it had a clockwork motor wind. There was nothing else like it. It came on to the market in the early 1960s at a price of £66, which included a winder which could be used in daylight for transferring 35 mm film from a standard cassette into special Tessina cassettes to give around twenty-four exposures. The image size was a

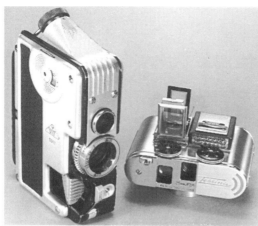

75. (From left) Twin-lens reflex Minicord and Tessina cameras.

generous 21 mm x 14 mm, almost as large as a half-frame negative. The small dimensions were achieved by using mirrors to reflect light from the taking lens down on to the film and from the viewing lens up to the viewfinder. The waist-level finder was so tiny that focusing and viewing were not easy but an eight-times magnifying finder or a pentaprism could be bought which fitted over the ground glass. The makers were Concava, in Switzerland, who continued to make the camera to order for many years after its launch.

Relatively few cameras used the 24 mm square format on 35 mm film. The Photavit was a very small camera of conventional shape which used 35 mm in small cassettes which were filled from a normal cassette using a daylight winder supplied with the camera. Like Zeiss Ikon's Tenax I camera, it was made both before and

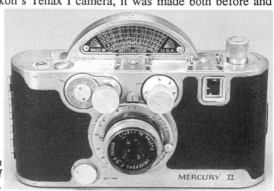

76. American Mercury II camera.

after the war. The Tenax I used normal cassettes to give fifty exposures and the film was advanced by pushing down on a large lever by the side of the shutter. The Radix camera also took 24 mm square pictures but used Agfa Karat film, which gave a more convenient sixteen exposures. It was a relatively simple and cheap camera which was supplied in a tinplate box decorated with a picture of the camera.

The Robot camera, which is described in chapter 7, was restricted by its circular shutter design to the smaller 24 mm square format. A 36 mm long negative would have needed a shutter of greater diameter housed in a much larger body. Another camera with a circular shutter was the Mercury II by the Universal Camera Corporation in the USA. It used the 18 mm x 24 mm format on 35 mm film and was on the market soon after the war ended. At that time the term 'half-frame' was not yet in use for this size. It was as large, if not larger, than most 24 mm x 36 mm cameras, mainly because space was needed for the circular shutter whose housing topped the camera in an arc. The camera was supplied with lenses from f2.0 to f3.5 and had shutter speeds up to 1/1000th second. It was one of the first cameras to have a flash-coupling contact in the centre of the accessory shoe and was very popular.

18 mm x 24 mm or half-frame cameras

In 1947, when foreign cameras could not be imported into Britain, the *Miniature Camera* magazine borrowed a new camera made in Italy called the Ducati. It took fifteen exposures, 18 mm x 24 mm, on 35 mm film loaded into small cassettes. The reviewer was greatly impressed with the quality of construction and the design, which included a coupled rangefinder and provision of interchangeable lenses in a camera body only about 10 cm long. On the sample tested, however, the lens definition was not very good. Probably not very many were sold because the camera is rare today.

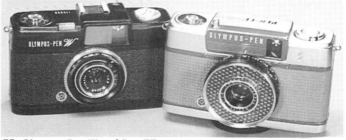

77. Olympus Pen W and Pen EE cameras.

To be successful commercially, a camera with a negative size of just 18 mm x 24 mm must have a lens capable both of resolving fine detail and giving good contrast. Both were certainly delivered by the Olympus Pen camera of late 1959. The specification was modest: an f3.5 lens of 28 mm focal length, manual focusing and no exposure meter. The results from a negative only half the size of the usual 35 mm camera were impressive. The camera was small, light and, with few projecting parts, it was easy to slip into a pocket or bag. The camera-buying public loved it. Olympus followed up with a new model, the Pen S, with an f2.8 lens but the camera came into its own when fitted with a selenium-cell exposure meter which surrounded the lens. The camera was called the Pen EE; EE stood for electric eye, for it had fully automatic exposure control. It cost £24 3s 0d in Britain in 1963; a full-frame 35 mm camera of similar specification, such as the Retinette IB, cost £31 10s 8d. Many different models followed and the Pen series remained in production for over twenty years.

The term 'half-frame' for the 18 mm x 24 mm format was adopted after the success of the Pen camera. Attempts were made in Britain to use the expression 'single frame' but this was later dropped.

78. (From left) Canon Dial and Canon Demi C cameras.

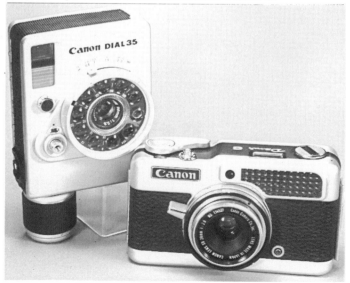

Other Japanese makers were not slow to follow Olympus' lead. Petri introduced their half-frame cameras in 1960. Like those of Olympus, they were offered with and without exposure meters, as the Compact E and the Petri Half. Minolta sold the Repro, Fuji the Fuji Half and Mini, and Ricoh sold the Caddy and included a spring-driven automatic film wind in the Ricoh Auto Half. Yashica made the tiny Mini and Yashica 72 and the much larger Yashica Sequelle and Rapide. Half-frame cameras of conventional design gave portrait rather than landscape pictures when held in the more comfortable, horizontal position. But most of the pictures people took were in the landscape format. Yashica solved the problem by turning their Rapide through ninety degrees and putting the viewfinder on the narrow end of the camera; they did the same with their Sequelle, which had motor wind as well. Not surprisingly it more closely resembled an 8 mm cine camera than a still, half-frame model.

Because the camera body was so small it could be hard to make a good viewfinder which gave a bright and easy to view image. Tiny eyepieces proved troublesome for spectacle wearers. Canon's Demi camera does not seem to have a viewfinder at all when seen from the front; there is just a small round spot above the lens. The finder used four lenses and three prisms and gave a very bright image. The f2.8 five-glass lens impressed the reviewer when it was tested by the *British Journal of Photography*. Canon also made their Canon Dial camera to be held easily for landscape format pictures. Like the Sequelle, it had a clockwork film wind. The camera used a CdS meter and the film speed was set by rotating what looked like a telephone dial on the front of the camera. Its unusual appearance and excellent lens made it a popular and very handy camera.

79. *(From left) Agfa Parat-I and Fuji Half 1.9 cameras.*

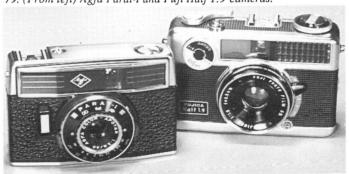

Some half-frame cameras were later made to take advantage of Agfa's Rapid instant-loading cassettes. Not only were they simple to load, they gave a very convenient twenty-four exposures on a film compared with forty or seventy-two from a standard 35 mm cassette.

Agfa, however, one of the few German companies to make a half-frame camera, used the full-sized cassette for their neat Parat cameras. The Parat 1 had an f2.8 Apotar lens in a three-speed shutter and a lightweight plastic body. It cost only £12 19s 6d. The Paramat was the fully automatic exposure version of the same camera. The Penti, from East Germany, was another small and cheap 18 mm x 24 mm camera, which had a shiny finish to its very rounded body. Although it was subsequently possible to use it with Rapid cassettes, it was introduced before they were launched; the intended film was the Agfa Karat cassette. The film was wound on by means of a plunger which popped out of the right-hand side of the body.

Olympus followed up their success with the Pen range of cameras by introducing a single-lens reflex camera of the same format, the Pen F. To keep the top of the camera flat, in line with the compact image of the format, prisms and lenses were used in place of a pentaprism in the viewing system. The rotary shutter was made of metal and was positioned just behind the lens. It operated so quickly that little or no distortion was seen in pictures of rapidly moving objects and it was synchronised for electronic flash at the maximum speed of 1/500th second. The mirror moved sideways and operated at twice the speed of full-frame reflexes. It came with a good range of interchangeable lenses and a clip-on meter which coupled with the shutter. The later Pen Ft had a through-the-lens metering system.

The Pen F camera had many admirers and it was launched at a time when many observers thought that the days of the full-frame camera were numbered. The popularity of the half-frame camera rose so quickly in the early 1960s that it seemed for a time that it might replace the 24 mm x 36 mm camera, at least for amateur use. It was particularly popular in Japan, especially in the mid 1960s. However, the size did have its drawbacks. Most makers of colour slide film did not mount the half-frame pictures; the film was returned as a strip with a set of empty mounts. Slide mounting, always a tedious job, was made worse by the small size of the transparencies. Colour prints, although gaining ground rapidly, were still much more expensive than black and white pictures. The size of the bill for a full set of seventy-two prints was quite daunting at around £7 10s 0d. Slide projectors gave only small images when used in normal living rooms.

By 1960 too many full-frame cameras had become large and heavy. The public seemed to prefer the small, pocketable, light and easy-to-use half-frame cameras, at least for a while. But it was the subsequent arrival of the truly compact full-frame camera which caused the demise of the half-frame format; but that came after the end of the period covered by this book.

7

Special-purpose cameras

Photographs which develop within seconds of being taken, stereo-oscopic pictures, underwater photographs, very wide-angle shots and photographs taken in rapid succession need to be made with specially designed cameras. Some interesting models were sold between 1945 and 1965.

Underwater photography

Underwater photography became much easier after the invention of the aqualung and was brought to the attention of a wide audience through film, television programmes and magazine articles dealing with the underwater activities of pioneers such as Jacques Cousteau. Soon other professional and amateur photographers wanted to take photographs underwater. In the 1950s it was possible to buy special waterproof housings for cameras which were designed to withstand the increased pressure when operated many metres underwater. The designers of these housings had to make it possible for the user to release the shutter, wind the film and, possibly, to provide for synchronised flash photography. Not surprisingly the housings had to be rather large and robustly built to withstand the water pressure and be fitted with oversized knobs and levers to facilitate handling. R. G. Lewis, for example, offered them to fit a number of different cameras.

In 1960 the French company Spirotechnique launched the Calypso, a 35 mm, self-contained underwater camera, which was named after Commander Cousteau's research vessel. It looked like a slightly larger than usual 35 mm viewfinder camera, with a grey, imitation sealskin covering; the lens was sealed behind a large glass disc. It could be used either under or above water and was handy to have on a beach since there was no danger of getting sand in the works. Remarkably, the lens assembly was interchangeable and alternative focal length lenses were available. It was made in France only for about three years, after which the rights passed to Nikon, in Japan, who continued its production as the Nikonos camera.

Wide-angle cameras

Many coupled rangefinder and single-lens reflex cameras would accept interchangeable wide-angle lenses but a few cameras were made with fixed wide-angle lenses. The Envoy Wide Angle camera took either roll film or glass plates for 6 cm x 9 cm negatives. A

normal focal length lens for this size is about 105 mm but the Envoy camera was fitted with a 60 mm Dallmeyer lens. It was designed primarily for professional use. A very wide-angle Hasselblad camera, the Super Wide Angle or SWA, was sold from around 1954. It used a 38 mm lens in a shortened non-reflex body, which still used the standard magazine back. The wide-angle version of the Rolleiflex camera has been mentioned in the chapter on reflex cameras.

A few Japanese makers brought out wide-angle versions of their 35 mm cameras. The Kowa SW of 1964 had a fixed 28 mm lens; the 1957 Mamiya Wide had a lens of 35 mm focal length, as did the several versions of the Olympus Wide, which was made about the same time. In later years a focal length of 35 mm came to be regarded as close to a standard focal length by many photographers. Olympus even sold a wide-angle version of their famous Pen half-frame cameras called the Pen W. However, the best way of encompassing a very wide field of view, whilst still retaining a reasonable perspective, is to use a lens of a focal length that is not too short but which is made to swing through an arc. To maintain the film at a constant distance from the back of the lens, it has to be held over a curved track. The system, which was popular with large roll-film cameras in the 1890s, was used again in the 1950s.

A limited number of Panon cameras were made in Japan in the 1950s for professional use. The Panon used a 50 mm lens which swung through an arc to give a field of view of 140 degrees. It took six pictures 4^{1}/2 inches long by 2 inches high on 120 roll film. 35 mm film was used in the Widelux camera, another expensive professional tool. Its negative size of 60 mm x 24 mm meant that it

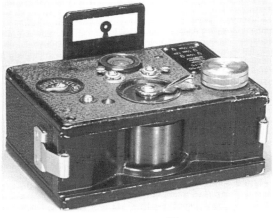

80. FT-2 panoramic camera from the USSR.

95

could be used in a 6 cm x 6 cm enlarger. As in the Panon, the light from the lens reached the film via a narrow slot at the end of a flattened tube fixed to the back of the lens. A cheaper 35 mm camera came from the USSR, the FT-2, which made a picture 110 mm x 24 mm from its 50 mm lens. It had rather a crude boxy shape but cost only £27 18s 0d in 1963. A swinging lens panoramic camera was even made as a subminiature camera using 16 mm film to take pictures 10 mm x 52 mm. The Viscawide of 1961 had a field of view of 110 degrees and the film had to be held in a special cassette which fitted around the curved film plane.

Rapid film-wind cameras

Although plungers, levers around the lens mount and triggers in the camera base were all tried in the 1950s to speed up the winding of film in 35 mm cameras, the most successful method was the lever wind operated by the thumb. Faster film-winding speeds were obtained by fitting clockwork drives into the bodies of the cameras which were linked to the shutter release and shutter cocking mechanisms. The Robot camera was launched in the 1930s and was much used during wartime for military research and record work. The model IIa of 1951, which was little changed from pre-war days, took 24 mm square pictures using a rotating disc shutter which had an open segment for making the exposure. A large knob on the camera's top was turned to wind up a spring which was used to drive the motor which advanced the film. Pictures could be taken just as quickly as it was possible to move the taking finger up and down on the release button. Although the camera did not have a rangefinder the lens was interchangeable. The Robot Royal III of 1953, later called the Royal 24, was a very fine camera which had bayonet-mounted alternative lenses and a coupled rangefinder. A switch on the camera gave the choice of a single shot or a sequence of pictures, up to eight shots a second, for as long as pressure was applied to the release. The Royal 36 took the conventional size 24 mm x 36 mm photographs.

The Leningrad, unlike a number of other cameras from the USSR, was a unique design. It took interchangeable lenses, with Leica size screw mounts, which coupled to the rangefinder. It had a cloth focal plane shutter with speeds from one second to 1/1000th second and a large knob to tension the spring. On pressing the release the shutter fired, the film wound on and the shutter blinds were returned to their starting position. Up to ten photographs could be taken at up to three a second. The price in 1963 was £58 12s 0d with an f2 lens. The Foton, by Bell & Howell in the USA, was even faster. It, too, had a focal plane shutter and a coupled rangefinder with alternative lenses. Bell & Howell were well-

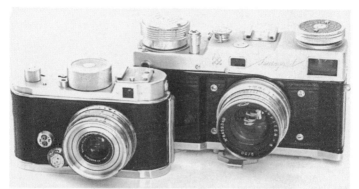

81. Robot IIa and Leningrad cameras with mechanical automatic film winding.

known for their beautifully made movie cameras so perhaps it was not surprising that the Foton had a claimed shooting rate of six shots a second. Its price in 1949 was an incredible $700 and, although this dropped to $498 a year later, sales were very low.

Stereoscopic cameras

The left and right eyes see slightly different views but the brain combines the separate images into one and allows us clearly to see that one object lies behind another. In other words we have binocular vision. Photographs of subjects which looked attractive at the time they were taken often look flat and muddled when seen as a normal print or slide because they have lost the feeling of depth. By taking separate photographs from positions just a few centimetres apart, and viewing the resulting pictures so that the left eye sees only the left-hand image and the right eye the right-hand image, the feeling of depth is restored. That is the basis for stereoscopic photography, which has enjoyed a number of periods of great popularity followed by many years of neglect. During the 1950s the ready availability and good quality of colour slide film led to another popular spell.

Stereoscopic cameras usually have two lenses, carefully matched for focal length, mounted side by side 6.5 cm apart, similar to the distance between the eyes of most people. The French company Jules Richard had specialised in stereoscopic photography since the late nineteenth century. They made the first 35 mm stereoscopic camera around 1920 but it was not very popular. The war interrupted the development of a modern 35 mm camera, the Verascope F40, which was relaunched shortly after the war ended.

It made pairs of pictures 24 mm x 30 mm or it could be switched over to single shots, even in mid film. It had excellent quality lenses, a coupled rangefinder and a shutter which guaranteed exactly the same exposure for each of the pair of pictures. Jules Richard completed the system by offering a range of viewers and a projector. This beautifully made camera stayed in production for at least twenty years but was always expensive. In 1960 the UK price was £222 6s 0d when a Leica IIIg, with f2 lens, cost £116 19s 9d.

An American-made 35 mm stereoscopic camera called the Stereo-Realist was launched in 1947. It, too, had a coupled rangefinder and good-quality lenses and it had shutter speeds from one second to 1/150th second. It was made by the David White Company and it was strongly promoted using advertisements of film stars and other well-known people holding their Stereo-Realist cameras. The designer chose a film format of about 22 mm x 23 mm, a size which in time became an international standard for stereoscopic photography. An excellent battery-powered illuminated viewer was made to go with the camera, as well as a slide-mounting jig. Later Eastman Kodak offered a service of mounting Kodachrome stereoscopic pairs in cardboard mounts. Several American-made 35 mm stereoscopic cameras followed after the success of the Stereo-Realist and they used the same format size. Around 1953-4 the Revere 33, the Videon II, Bell & Howell's Stereo Colorist and Kodak's Stereo 35 came on to the market. The Graflex Corpora-

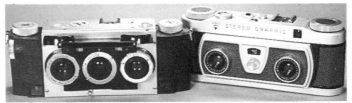

82. *(From left) Stereo-Realist and Wray Stereo-Graphic cameras.*

tion made one of the cheaper 35 mm stereoscopic cameras, the Stereo-Graphic. It had a single-speed shutter and fixed focus f4 lenses. One of the lenses was focused at infinity, the other at around 5 feet (1.5 metres). By the time the two images fused into one in the stereoscope, everything was supposed to appear sharp. The same camera was made under licence in Britain by Wray (Optical Works) Ltd and cost £22 11s 0d in 1957.

The first 35 mm stereoscopic cameras from Germany were the Stereo Iloca cameras models I and II. Model I used the 24 mm x 30 mm size established by the Verascope F40; the model II followed American practice. In later models only the American format was

used. Edixa also made stereoscopic models. Model I had matched f3.5 lenses and Pronto shutters and cost £41 14s 0d in 1956; model II had the added benefit of a coupled rangefinder, and the top-of-the-range model III had a built-in exposure meter which brought the price up to £75 12s 0d. Very few 35 mm stereoscopic cameras were made in Japan; perhaps only the Owla achieved reasonable sales.

Sawyers had an enormous success with their View-Master system. A cardboard disc containing a number of very small transparencies was placed in a stereoscopic viewer which brought each scene into view by pulling down on a lever. Millions of discs were sold, mainly of views of famous places, but popular cartoon characters were also included. From the early 1950s it was possible for snapshooters to make their own pictures by means of the View-Master Personal Camera. It used 35 mm film which had to be put through the camera a second time to make all sixty-nine pairs of pictures, each 12 mm x 13 mm. The fingernail size pieces of film had to be cut out and placed in blank View-Master discs. To make this task easier, a jig was supplied as an accessory. A later camera was made in Germany for Sawyers in which only one pass of the film was necessary. The Czech company Meopta also made a camera, the Stereo 35, which took View-Master sized pictures, and even a stereoscopic version of their Mikroma 16 mm camera.

Roll film was used by a number of makers of stereoscopic cameras. The Coronet Stereoscopic or 3D camera was made in Britain and took four pairs on 127 roll film. The camera, which was merely a cheap plastic snapshot model, was sold with a viewer for the prints and cost £3 6s 8d in 1956. The Italian Iso Duplex camera of the later 1950s took a pair of pictures across the width of a roll of 120 film. The photographs were just about the same size as those made by the American-size 35 mm stereoscopic cameras so they could be seen with the readily available hand viewers and stereoscopic projectors.

83. Subminiature stereoscopic camera, the Stereo-Mikroma.

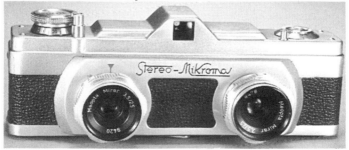

84. Italian Iso Duplex
Super 120 camera.

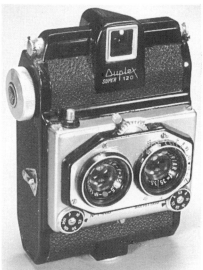

Instant pictures

One of the most remarkable developments of photography in the period after the Second World War was the invention and marketing of a system for producing high-quality prints only a minute after a picture was taken. The inventor was Edwin Land and the name of the camera and picture system he devised came from his established company: Polaroid. During the early 1940s Dr Land experimented with chemical processes in order to discover one which would allow someone with no chemical or photographic knowledge to take a photograph and, no more than a minute later, be able to see the finished photograph which would be ready to put straight into an album. For decades there had been methods, such as the tintype, which were used by out-of-doors photographers to take souvenir photographs of holidaymakers and to present them with the finished photograph a minute or two later. But these cameras needed light-tight containers of chemical solutions and the photographer had to arrange for the picture to be transferred from one to the other. Frequently the results were drab and often they were not very stable.

Edwin Land tried a different approach. He found that he could dissolve the chemicals remaining in the surface of a negative and let them diffuse into a sheet of specially prepared white paper, where they were turned into a black and white image. The dark parts of the negative formed the light parts of the print. The

100

solution and transfer of the chemicals were brought about by spreading a thin film of a special chemical solution between the film and paper an instant before they were sandwiched together. Both Agfa and Gevaert used similar methods in their early photo-copying machines. But Dr Land had to invent a camera to contain the negative material, the special white paper and the chemicals to spread between them.

The first Polaroid Land Camera, the model 95, went on sale in 1948. The print size was $3^1/4$ inches x $4^1/4$ inches (9 cm x 11 cm), including the white margin, a size then popular for prints. It was a large folding bellows camera, with a brown imitation-leather covering, an f11 lens and a simple exposure system. The film had a conventional black backing paper on to which was attached, part way down its length, a roll of negative material and, a little further down, a second roll of the special white paper. After exposure a catch released the film so that a firm pull on the black paper, which projected from the end of the camera, brought the negative face to face with a section of the special white paper. At the same time a waterproof pod was broken between a set of rollers which released a tiny amount of concentrated chemical solution between the negative and the paper. After a minute a door was opened in the back of the camera and the finished print could be pulled away

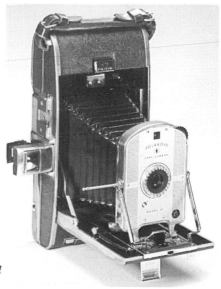

*85. Polaroid Land
Camera, the model 95.*

from its paper support. The photograph was just a little damp, but it soon dried off, and it did not need any further treatment.

The first Polaroid film was called Type 40 and it gave sepia pictures. The Polaroid system of photography became an immediate success. A very large number of model 95 cameras were sold including the models 95a and 95b, which had small improvements. By 1950 Type 41 film gave black and white pictures. To preserve the finished picture it had to be rubbed over with a coating stick impregnated with varnish and stabiliser solution. In 1954 the model 80 camera gave smaller pictures and, amongst a number of models which were issued in the following years, the 900 camera of 1960 was the first Polaroid camera to have fully automatic control of exposure. New films were introduced, some for specialised technical work since the Polaroid process was just as valuable for laboratory work and professional photography as it was for the snapshooter.

By the early 1960s colour prints were taking over from monochrome, especially in the United States. Amazingly, the research chemists at Polaroid were able to take the instant-print process a stage further and Polacolor instant colour print film was launched in 1963. In the same year an important new camera was introduced, the Polaroid Land Automatic 100 camera. The large and rather awkward roll system was replaced by a flat metal pack. This was slipped into the camera and the black paper safety cover was pulled clear of the camera. As it did so, it left a small black tag behind. After exposure this tag was pulled away, bringing the

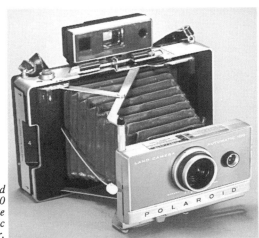

86. Polaroid Automatic 100 camera with the first electronic shutter.

negative and receiving paper together, with the layer of chemicals between them. This sandwich was pulled clear of the camera and, after 10 seconds for black and white pictures and a minute for colour, the sheets were parted to deliver the final print. With this new system the camera was much smaller and lighter than before. Best of all, it had the first transistorised electronic shutter to be fitted to any camera, which, together with a CdS cell exposure meter, formed part of a fully automatic exposure system. It gave fully automatic exposures from hundredths of a second to tens of seconds; it would even give the correct exposure for a portrait made by the light of a single candle. It was one of the stars of Photokina in 1963 and led the way to the large-scale replacement of mechanical shutters by electronic ones in later years.

8

Museums

The displays of cameras in the museums listed below usually cover the period from the Victorian era to beyond the Second World War. It is advisable to check opening times by telephone or website before paying a special visit.

Beck Isle Museum of Rural Life, Bridge Street, Pickering, North Yorkshire YO18 8DU. Telephone: 01751 473653.

The museum has a photographic gallery devoted to photographic images, equipment and processes. The displays illustrate the development of the camera and its accessories from the late nineteenth century to the modern single-lens reflex.

The British Photographic Museum, Bowden House, Totnes, Devon TQ9 7PW. Telephone: 01803 863664.

The old coach-house and stables have been converted into a museum which houses thousands of cameras, both still and movie, in a series of imaginative displays.

Fox Talbot Museum, Lacock, Chippenham, Wiltshire SN15 2LG. Telephone: 01249 730459. Website: www.r-cube.co.uk/fox-talbot/

Lacock Abbey was the home of William Henry Fox Talbot, the inventor of the negative/positive system of photography. The museum, which is housed in a former barn by the Abbey entrance, covers all the achievements of this remarkable man, but photography has pride of place. There is a good photographic bookshop in the entrance lobby.

'How We Lived Then', Museum of Shops and Social History, 20 Cornfield Terrace, Eastbourne, East Sussex BN21 4NS. Telephone: 01323 737143.

Jersey Photographic Museum, Hôtel de France, St Saviour's Road, St Helier, Jersey JE2 7LA. Telephone: 01534 614700.

The museum houses a permanent display of every model of Rolleiflex and Rolleicord camera with changing displays of cameras by other makers.

Leeds Industrial Museum, Armley Mills, Canal Road, Armley, Leeds, West Yorkshire LS12 2QF. Telephone: 0113 263 7861. Website: www.leeds.gov.uk

The museum contains a display about the Kershaw Company, which was based in Leeds, including some cameras made by the company.

Museum of the History of Science, Old Ashmolean Building, Broad Street, Oxford OX1 3AZ. Telephone: 01865 277280. Website: www.mhs.ox.ac.uk

In an elegant building are housed superb microscopes, telescopes,

surveying instruments and chemical apparatus amongst a wide range of historical scientific equipment. A small number of cameras and some related processing equipment are on display. Lewis Carroll (the Reverend Charles Dodgson) was a talented photographer and Oxford don as well as author of the 'Alice' books. Some of his processing equipment is in the collection.

Museum of Science and Industry in Manchester, Liverpool Road, Castlefield, Manchester M3 4FP. Telephone: 0161 832 2244. Website: www.msim.org.uk

The photographic collections have been brought together in a 'Collected Cameras' exhibition which covers photography from its origins to the present day. There is a special emphasis on the development of photography in Manchester with examples by Dancer, Chapman and Thornton-Pickard.

National Museum of Photography, Film and Television, Pictureville, Bradford, West Yorkshire BD1 1NQ. Telephone: 01274 202030. Website: www.nmpft.org.uk

This superb museum covers all aspects of still and motion picture photography. In addition to excellent displays of old cameras and the history of photography it is now possible to view items from the reserve collection in a specially built research centre.

Robert D. Clapperton Photographic Trust, Clapperton's Daylight Photographic Studio, 28 Scott's Place, Selkirk TD7 4DR. Telephone: 01750 720523. Website: http://website.lineone.net/~ian.w.mitchell

The studio was established in 1867 and was run by three generations of the Clapperton family until the 1980s. It welcomes visitors to see the studio, which is set up as a working museum and photographic archive.

The Royal Photographic Society. Website: www.rps.org

The Royal Photographic Society has closed its museum and galleries in Bath. However, it is planning to set up a new centre for its collections that will include displays and access for researchers. Up-to-date information will appear on its website.

Science Museum, Exhibition Road, South Kensington, London SW7 2DD. Telephone: 0870 870 4868. Website: www.nmsi.ac.uk

Two circular galleries take the visitor through the whole history of photography from its earliest days to holography.

The Time Machine Museum, North Somerset Museum Service, Burlington Street, Weston-super-Mare, Somerset BS23 1PR. Telephone: 01934 621028. Website: www.n-somerset.gov.uk/museum

This attractive museum has over 350 items of photographic equipment, of which about thirty cameras are on display, and reserve items in the collection can be viewed by appointment.

9
Books and internet sites

History of the camera and collecting cameras
Channing, Norman, and Dunn, Mike. *British Camera Makers – An A–Z Guide to Companies and Products.* Parkland Designs, 1996.
Matanle, Ivor. *Collecting and Using Classic Cameras.* Thames & Hudson, 1992.
Matanle, Ivor. *Collecting and Using Classic SLRs.* Thames & Hudson, 1996.
Pritchard, Michael, and St Denny, Douglas. *Spy Cameras – A Century of Detective and Subminiature Cameras.* Classic Collection Publications, 1993.
Rouse, Kate. *The First-Time Collector's Guide to Classic Cameras.* The Apple Press, 1994. Colour illustrations and limited text.
Wade, John. *The Collector's Guide to Classic Cameras 1945–1985.* Hove Books, 1999.
White, Robert. *Discovering Old Cameras 1839–1939.* Shire Publications, third edition 1995; reprinted 2001.
White, William. *Subminiature Photography.* Focal Press, 1990.

Out of print
This book is well worth looking for second-hand.
Coe, Brian. *Cameras. From Daguerreotypes to Instant Pictures.* Marshall Cavendish Editions, 1978. An excellent book on the history of the camera.

Camera lists and price guides
Illustrated lists of cameras can be very useful for tracking down the date of manufacture, the name of the maker and other information about a particular camera. Some lists are in the form of 'price guides' in which the compiler has attempted to give some indication of the price a collector might have to pay for a camera in first-class condition from information gathered from auction sales, camera fairs, dealers' lists and so on.

McKeown's Price Guide to Antique and Classic Cameras 2000–2001. The most complete of the lists, containing a good deal of information about the cameras and their manufacturers, in addition to an indication of value.
The Hove International Blue Book – The Illustrated Price Guide to Collectable Cameras and *Kadlubeks Kamera-Katalog* in English and German are lower-priced 'price guides'.

Some books contain hundreds of photographs and line illustrations of cameras with just a line or two of information about each of them. Two examples are:

From Daguerre to Today. Abring.
Michel Auer's Collector's Guide.

Cameras from individual manufacturers
Aguila, Clément, and Rouah, Michel. *Exakta Cameras.* Hove Foto Books.
Coe, Brian. *Kodak Cameras – The First Hundred Years.* Hove Photo Books.
Dechert, Peter. *Canon Rangefinder Cameras.* Hove Foto Books.
Laney, Dennis. *Leica Collector's Guide.* Hove Collectors Books.
Parker, Ian. *Complete Rollei TLR Collector's Guide.* Hove Foto Books.

Rogliatti, G. *Leica – The First 70 Years.* Hove Collectors Books.
Rotoloni, Robert. *Nikon Rangefinder Camera.* Hove Foto Books.

A number of other makers have been the subject of books and pamphlets, several of them in French or German. Please see the list of book suppliers for information on how these may be seen or purchased.

Books listing or describing cameras from a particular country are available for Belgium and Holland, China, France, Germany, Great Britain, Japan and Russia.

Book suppliers

Since most books on the history of the camera or on camera-collecting do not have wide appeal they cannot usually be found in local bookshops. However, there are now some bookshops, or book departments within shops selling old cameras, where a large range of books may be seen. The intending buyer is strongly recommended to visit one of these shops to see the books and to discuss requirements with one of the knowledgeable members of staff. New books and 'listings' are being issued quite frequently, making a visit even more worth while. For those who cannot pay a visit, lists of both new and second-hand books on offer may be available by post.

The Antique Camera Company, Andrews Cameras, 16 Broad Street, Teddington, Middlesex TW11 8RF. Telephone: 020 8977 1064. Fax: 020 8977 4716. Website: www.andrewscameras.co.uk Long list of books for collectors.
Jessop Classic Photographica, 67 Great Russell Street, London WC1. Telephone: 020 7831 3640. Fax: 020 7831 9356. Website. www.jessops.com/classic/

Some camera museums and photographic galleries also have book counters but their range will be less than in the specialist shops.

Old Timer Cameras Ltd, PO Box 28, Elstree, Hertfordshire WD6 4SY (telephone: 020 8953 2263; fax: 020 8905 1705; website: www.oldtimercameras.co.uk) offers a valuable range of postal services. These include camera instruction books, reprints of test reports, camera guides and camera repair manuals.

THE INTERNET

There are hundreds of websites of interest to camera collectors and historians. Below are a few that combine useful information with good links to other relevant sites.

History of photography

www.rleggat.com/photohistory
http://www.photojpn.org/HIST/hist1.html
www.well.com/user/silver/inphohome.html
www.nmpft.org.uk/home.asp

Camera collecting

www.photoshot.com
www.camprice.com
www.azalea.net/~scrib/CAMLINKS.HTM

BOOKS AND INTERNET SITES

Specific camera types and makers

Zeiss Ikon and Carl Zeiss
http://johnlind.tripod.com/zi/zeissikontext.html
www.companyseven.com/zeiss/history.html

Subminiature cameras
www.subclub.org/index.htm

Leica, Nikon and other classic cameras
www.cameraquest.com/classics.htm
www.fortunecity.com/meltingpot/lawrence/250/camlinks.html

Kodak
www.kodak.co.uk/US/en/corp/aboutKodak/kodakHistory/kodak.shtml
http://user.itl.net/%7Ekypfer/intro.htm

Exakta
www.ihagee.org
www.exaktacircle.org.uk

Wooden cameras
www.usinternet.com/users/rniederman/cameras.htm
http://members.aol.com/dcolucci/index.html

Graflex
www.graflex.org

Canon
www.canon.com/camera-museum/index.html

Ensign
www.photohist-ensign.demon.co.uk

Topcon and Rectaflex
www.marcoant.com

French cameras after 1940
http://clicclac.free.fr/Appareils_francais.htm

Auction houses

Christies South Kensington, 85 Old Brompton Road, London SW7 3LD. Telephone: 020 7581 7611. Website: www.christies.com

Christies holds auction sales of collectable cameras several times a year. They produce well-illustrated catalogues for each sale with background notes on some of the more unusual cameras. Viewing days provide an excellent opportunity of seeing some rare and interesting cameras.

10

Organisations

Club Rollei: details from Jersey Photographic Museum, Hôtel de France, St Saviour's Road, St Helier, Jersey, Channel Islands JE1 7XP. Telephone: 01534 614700. Website: www.style2000.com/rollei_info.html
 A club for collectors, researchers and users of Rolleiflex and Rolleicord cameras.

The Exakta Circle: details from the Secretary, 24 Orchard Road, Alderton, Tewkesbury, Gloucestershire GL20 8NS. Telephone: 01242 620737. Website: www.exaktacircle.org.uk/news.htm
 A club with an international membership for anyone interested in collecting, using and researching the history of Exakta equipment.

The Historical Group of The Royal Photographic Society: details from the Secretary General, Royal Photographic Society, The Octagon, Milsom Street, Bath BA1 1DN. Telephone: 01225 462841. Fax: 01225 448688. Website: www.rps.org
 The Group's interests cover the whole field of the history of photography.

The Leica Historical Society: details from the Membership Secretary, Dr G. Hughes, 69 Love Lane, Pinner, Middlesex HA5 3CY. Telephone: 020 8866 7098.
 One of the first British societies for camera collectors and historians.

Photographic Collectors Club of Great Britain: details from the Membership Secretary, 5 Buntingford Road, Puckeridge, Ware SG11 1RT. Telephone: 01920 821611. Website: www.lightwave.demon.co.uk/pccgb/options.htm
 The club, which has over a thousand members, holds meetings all over Britain and publishes a regular magazine and newsletter. Its members are principally interested in collecting cameras and related equipment.

The Stereoscopic Society: details from the Secretary, 36 Silverthorn Drive, Hemel Hempstead, Hertfordshire HP3 8BX. Telephone: 01442 258805. Website: www.stereoscopicsociety.org.uk
 Founded in 1893, the Stereoscopic Society covers a wide range of 3-D photography interests and has approximately 650 members both in Britian and other countries.

Voigtländer Verein: details from the secretary, Chris Haupt, 33 Woodhayes Road, Frome, Somerset BA11 2DG. Telephone: 01373 463145. Website: www.bubley.com/verein Email: mycrease@btinternet.com
 A United Kingdom association for collectors and users of Voigtländer equipment.

Index

INDEX